BASEBALL
IN
BALTIMORE

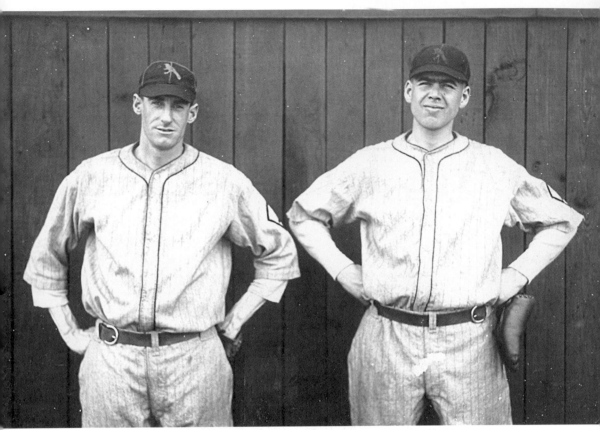

CLAYTON SHEEDY AND GEORGE EARNSHAW, 1924. One in a series of unique two-player promotional shots from 1924, this image features first baseman Clayton Sheedy and pitcher George Earnshaw and exemplifies the excellence of Jack Dunn's 1920s International League Orioles. Sheedy starred in track and baseball for Georgetown and, upon graduation in 1923, joined the Orioles and made an instant impact. Earnshaw, a Swarthmore graduate, joined the club in 1924 and promptly went 7-0 before winning a remarkable 29 games the following season. He would go on to win 127 major-league games, including three consecutive 20-win seasons from 1929 to 1931 for the Philadelphia A's. Judging by the expression on his face here, the young right-hander appears uncertain of just what to make of the two-man photo shoot. (National Baseball Hall of Fame Library, Cooperstown, New York.)

FRONT COVER: Catcher Sherm Lollar was a key part of the 1944 International League champion Orioles and went on to an 18-year major-league career. (Blair Jett.)

COVER BACKGROUND: This is the 1949 Baltimore Elite Giants pitching staff that led the team to the Negro American League pennant. (The Maryland Historical Society.)

BACK COVER: Cal Ripken Jr. laces a hit in 1997. The Orioles spent the entire 1997 regular season in first place. (National Baseball Hall of Fame Library, Cooperstown, New York.)

BASEBALL
IN
BALTIMORE

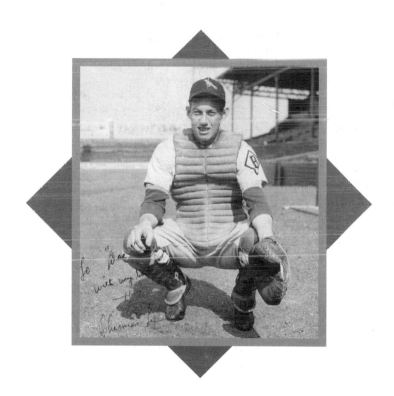

Tom Flynn
Foreword by Sean Welsh of the Baltimore Examiner

ARCADIA
PUBLISHING

Published by Arcadia Publishing
Charleston SC, Chicago IL, Portsmouth NH, San Francisco CA

Printed in the United States of America

Library of Congress Catalog Card Number: 2007933425

For all general information contact Arcadia Publishing at:
Telephone 843-853-2070
Fax 843-853-0044
E-mail sales@arcadiapublishing.com
For customer service and orders:
Toll-Free 1-888-313-2665

Visit us on the Internet at www.arcadiapublishing.com

To my father, for the gift of baseball

CONTENTS

Acknowledgments 6

Foreword 7

1. The Road to the "Old Orioles": 1860–1899 9

2. Four Leagues: 1900–1915 27

3. St. Mary's Wonder: Babe Ruth 43

4. The International League O's: 1916–1928 55

5. The International League O's: 1929–1953 67

6. Black Sox and Elites: Negro League Baseball 81

7. Back in the Majors: 1954–Present 93

8. Places Called Home: Baltimore's Ballparks 111

ACKNOWLEDGMENTS

Thanks to John Horne, Andrew Newman, and Freddy Berowski at the National Baseball Hall of Fame Library and Greg Schwalenberg and Shawn Herne at the Sports Legends Museum at Camden Yards. A fell-swoop thanks to Chris Becker, Blair Jett, Mark Rucker, Jeff Korman, Anthony Amobi, and Marsha Wight Wise for all their extra efforts. Finally, thanks to Michele for her encouragement, enthusiasm, and endless support, and to Charlie, Neal, and Jack for all of their useful ideas.

Three books amongst many that were invaluable and should be required reading for any fan of Baltimore baseball include:

Marshall D. Wright's *The International League: Year-by-Year Statistics, 1884–1953* (McFarland and Company, 2005)
Leigh Montville's *The Big Bam: The Life and Times of Babe Ruth* (Broadway Books, 2006)
James Bready's *The Home Team* (James H. Bready, 1975)

PHOTO LEGEND

The full credit line for items from the Enoch Pratt Library reads: "Courtesy of the Enoch Pratt Free Library, Central Library/State Library Resource Center, Baltimore, Maryland." The contributions noted as the Babe Ruth Museum are in conjunction with the Sports Legends Museum at Camden Yards, both guided by the Babe Ruth Birthplace Foundation, Inc. Credit lines for items from the author's collection are omitted.

FOREWORD

Like brick row homes, seafood, and the national anthem, baseball is part of the stitching that binds Baltimore.

Baseball began in Baltimore much like it did in other American hubs—as a game without much direction but with plenty of potential. As the two collectively grew, a partnership between the game and the city's eclectic mix of residents was born.

Early personalities like outfielders Joe Kelley and Willie Keeler, and manager Jack Dunn, built Baltimore into a legitimate baseball town. Homegrown talent like Western Maryland native Robert "Lefty" Grove, George Herman "Babe" Ruth of St. Mary's Industrial School, and Cal Ripken Jr. of Aberdeen High established the Baltimore area as fertile ground for baseball talent.

A legend today, Ruth grew up in Baltimore and played for the International League Orioles before eventually finding his greatest glory as a member of the hated Yankees. His birthplace on Emory Street still stands and is preserved as a museum.

The success of the Orioles was built in the 1960s and 1970s, when the likes of Brooks and Frank Robinson led the team to world championships in 1966 and 1970.

The growing fandom at Memorial Stadium only cemented baseball as a part of Baltimore. Today's centerpiece, Oriole Park at Camden Yards—the most picturesque of American ballparks—takes fans back to a time before interleague play, the wild card, and even night games. Ruth's father had a saloon in what is now shallow center field. With the historic brick B&O warehouse looming over right field, Camden Yards is a portal to a place where only still images can take us.

The ivy-covered wall beyond center and the brick barrier behind home plate whisper Wrigley. The 18-foot right-field scoreboard wall recalls Ebbets. The classic green color throughout evokes Fenway.

But in a fashion, each comes together to form a ballpark uniquely Baltimore. With the city skyline as its backdrop, Camden Yards is the perfect image to tie together a city with such a rich history in the game.

Baltimore baseball predates the Ripkens. It predates the Robinsons. It even predates Ruth.

From the early teams—such as the Excelsiors, the Lord Baltimores, and the early Orioles—through the Black Sox and Elites of the Negro Leagues, to the Orioles of today, *Baseball in Baltimore* captures the city's nearly 150-year fascination with the sport through an array of vintage images of the game.

—Sean Welsh

Born in Baltimore, Sean Welsh covers the Orioles for the *Baltimore Examiner*.

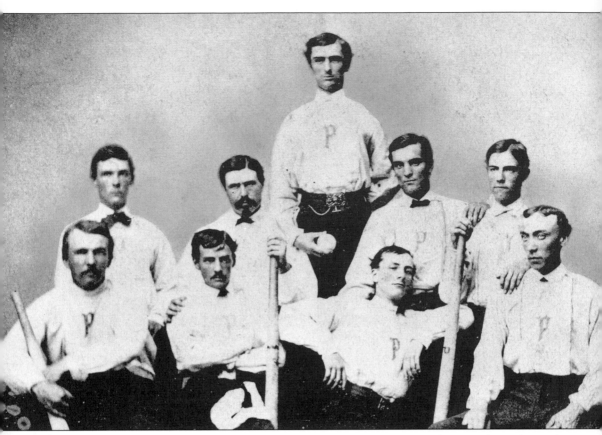

THE BALTIMORE PASTIMES, C. 1867. Looking very much the men of leisure, the earliest of Baltimore's "base ball" (as it was then spelled) players were largely businessmen who could afford the free time that Baltimore's working class could rarely spare. The Pastimes, pictured here, were the city's premiere baseball club for a portion of the 1860s. By the decade's end, the Maryland Base Ball Club, or Marylands, turned professional and surpassed the strictly amateur Pastimes. (The Babe Ruth Museum.)

THE ROAD TO THE "OLD ORIOLES"

1860–1899

Baseball in 19th-century America was consistent only in its steady change. Clubs formed and disbanded with regularity, rules changed frequently, and the difference in quality of teams improved from embarrassing disparity to rough parity as leagues began to form and gradually establish themselves as amateur, minor, or major in pay and quality.

In Baltimore, baseball followed the national trend. The city's first team of note was the Excelsiors, formed in the late 1850s by local businessmen inspired by a Brooklyn-based team of the same name. By September 1860, the sport's popularity within the city was strong enough to turn out 5,000 fans for an all-Excelsiors contest between Brooklyn and Baltimore. The next year, the team merged with a competing club and was dubbed the Pastimes.

By 1872, a professional team, league, and park were in the city. The Lord Baltimores played in the National Association (NA) at Newington Park. Crowds at the park varied widely from the hundreds to the thousands, but baseball was increasingly taking hold as a spectator sport in the city.

The National Association ultimately dissolved, with its stronger teams entering the rival National League (NL). The Lord Baltimores, finishing last in 1874, were left behind. It wasn't until 1882, with an entry in the rival American Association (AA), that Baltimore returned to a league of major-league quality. That team, the city's first to eventually be dubbed the Orioles, ultimately joined the National League along with several other American Association teams.

Here, finally, the city and its team enjoyed both stability and success. Finishing 12th in the NL in 1892 under manager Ned Hanlon, the Orioles steadily rose to 8th in 1893 and then to the top of the baseball world in 1894 for a three-year stay. The 1890s "Old Orioles" teams would significantly shape all of baseball's landscape for decades to follow, as they continued to play and manage well into the new century.

THE NON-MIGHTY DENNIS P. AND DANIEL CASEY. One AA Oriole, Dennis Casey (left), gained notoriety by virtue of his last name. Casey hit six home runs from 1884 to 1885. Although a modest sum, when viewed in conjunction with his last name they provide ample fodder (primarily in Baltimore) for his consideration as the source of inspiration for the 1888 poem "Casey at the Bat." Dennis was one of only three Caseys in the majors between 1871 and 1888. The other two, Daniel (Dennis's brother) and William, were pitchers. In 1938, an elderly Daniel Casey (below, flanked on his right by Rogers Hornsby) wove a tall tale before a cheering throng of thousands at Oriole Park proclaiming that he was the Casey of lore. The poem's likely inspiration was Boston's Michael "King" Kelly, whose name replaced Casey's in subsequent printings. (At left, the Babe Ruth Museum; below, © Bettmann/Corbis.)

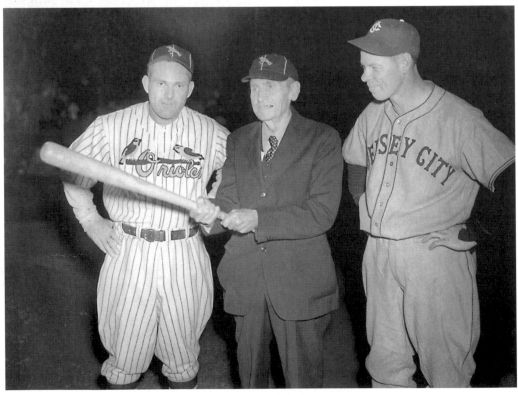

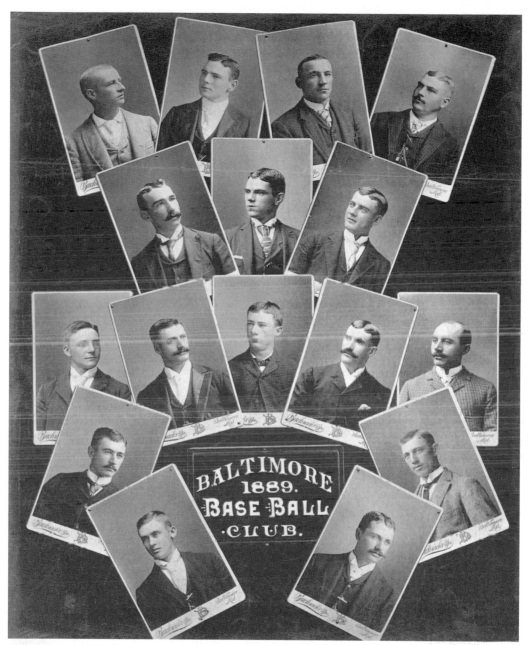

AMERICAN ASSOCIATION ORIOLES, 1889. Although the AA Orioles were unspectacular, they did include the incomparable Matt Kilroy. Kilroy (center, second row from top) pitched in Baltimore from 1886 to 1889 and struck out 1,082 batters while winning a remarkable 121 games. His 513 strikeouts in 1886 remains the all-time major-league record. For the lion's share of their tenure in the AA, the Orioles were led by Bill Barnie (not pictured here). "Bald Billy" managed the team from 1883 to 1891. Well liked by players but unsuccessful as a manager, Barnie moved on to direct three different National League teams in the 1890s. (© Corbis.)

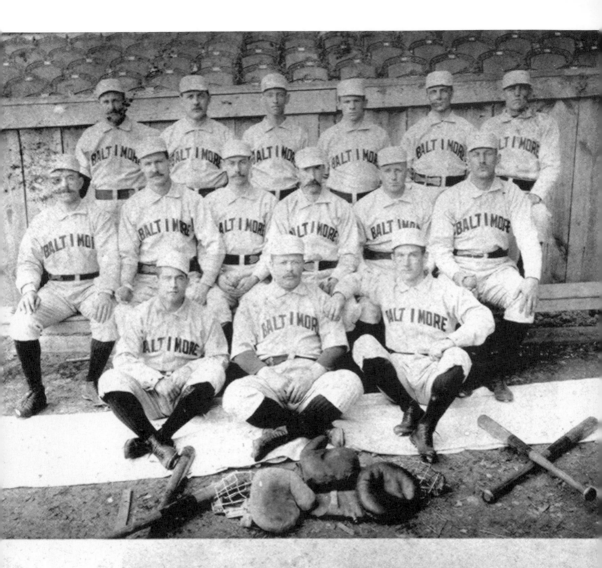

Baltimore Base Ball Club 1892.

INAUGURAL NATIONAL LEAGUE BALTIMORE ORIOLES, 1892. In 1892, the National League absorbed four AA teams after that league's demise the prior year. Baltimore was one of the fortunate four, and along with a franchise the National League gained two of its most important figures for the next four decades. Centered in the first row is catcher Wilbert Robinson, acquired from Philadelphia in late 1890 by Bill Barnie. In the third row, third from right, is third baseman John McGraw, perfecting a scowl that would rarely leave his face when near a baseball field in the ensuing years. In June 1892, the Orioles added perhaps the most important piece to the club. After a brief search for a replacement manager, 34-year-old Edward H. "Ned" Hanlon signed on to lead the team. (The Babe Ruth Museum.)

JOE KELLEY, OUTFIELDER, C. 1895.
Late in Hanlon's first year as manager with the Orioles, he quietly acquired outfielder Joe Kelley from the Pirates. It was an unremarkable trade for an unremarkable player; Kelley batted only .232 on the year. The next season, Hanlon dragged Kelley out on the field early each morning for extra work. The results were immediate. In 1893, Kelley batted .305 and only improved from there. (National Baseball Hall of Fame Library, Cooperstown, New York.)

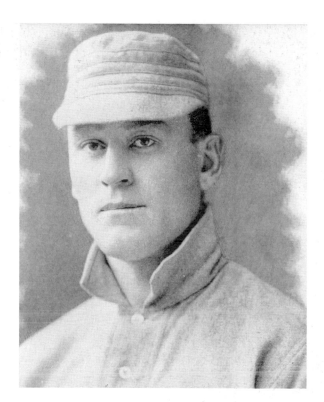

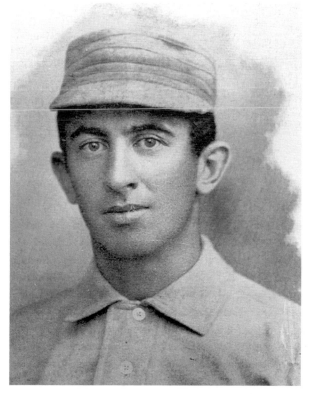

"WEE" WILLIE KEELER, OUTFIELDER, C. 1895. At 5 foot, 4 inches and 120 pounds, "Wee" Willie Keeler was aptly named. The nickname was also apt for the variety of baseball that he played; in today's terminology it would be dubbed "small ball." Keeler, acquired from Brooklyn before the 1894 season, excelled at the bunt, slap hit, and stolen base. (The Babe Ruth Museum.)

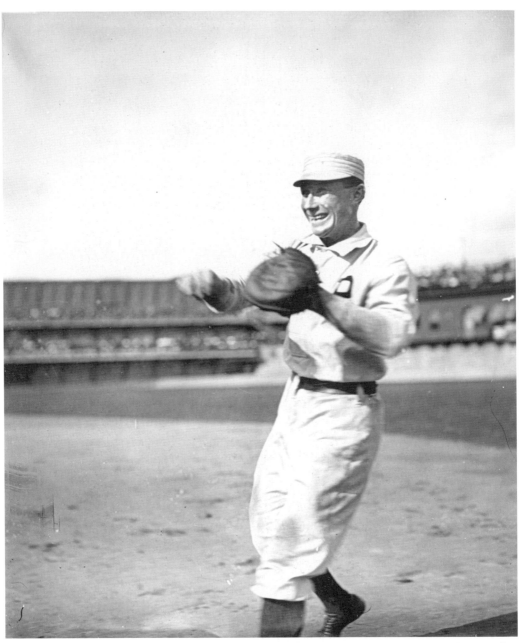

REASON TO SMILE, ORIOLES SHORTSTOP HUGHIE JENNINGS. This pregame photograph of Hughie Jennings smiling as he warms up is a true rarity. Just as it is difficult to picture the 19th-century Orioles in full color, it is equally hard to imagine them smiling on the diamond before facing an opponent. Arriving in Baltimore in 1893 batting just .136, Jennings proved another Hanlon project. He closed out 1893 by hitting .255 for the Orioles and was named team captain in 1894 while batting .335. His .401 average in 1896 remains the highest ever achieved by a shortstop. Jennings matched his batting with tremendous fielding and was also a great student both on the field and off, eventually graduating from Cornell. (The Babe Ruth Museum.)

THE ORIOLES, 1894.

1

We read of men whose names are found
 Upon the scroll of fame,
In drama, wit, and politics,
 In science, skill, and game.
The Orioles are written there,
 To watch them is a treat,
They are our champions, great and brave,
 They never know defeat.

2

Brave Robinson, their leader, is
 No better could be found,
No greater master of the game
 Upon the base-ball ground.
His team know well their Captain's skill,
 He's watched with pride and awe,
All honor to their Captain,
 To Brodie and McGraw.

3

McMahon, Hawke, and Esper too,
 And Gleason and Hemming, I guess,
Contribute largely to the game,
 And their record of success.
And one there is among the team,
 Who was never known to yield;
He plays with head as well as hands,
 'Tis Keeler in right field.

4

First baseman Brouthers plays a game
 That's steady, grand, and true,
And at his place, in all the league,
 His equals are but few.
The rolling years may come and go,
 But time can ne'er erase
The fine performances of Reitz,
 Who plays at second base.

5

In short-stop Jennings the Orioles have
 The finest of the day,
And for himself has rightly won
 The laurel and the bay.
Left-fielder Kelly plays the game,
 There is no doubt of that,
He's grand in his position
 And a wonder at the bat.

6

The pennant's yours, 'tis fairly won;
 And we all feel proud today;
'Twas not won by luck or fortune,
 But by vast superior play.
'Tis yours in eighteen-ninety-four,
 And as sure as we're alive,
No club shall take it from you
 In eighteen-ninety-five.

 H. M.

THE ORIOLES, 1894. The title of the poem says it all, as the Orioles captured their first pennant in 1894 by besting the second-place New York Giants. In a form of high praise that time has passed by, "H. M." penned this ode to the individual and collective feats of that year's Orioles. (The Babe Ruth Museum.)

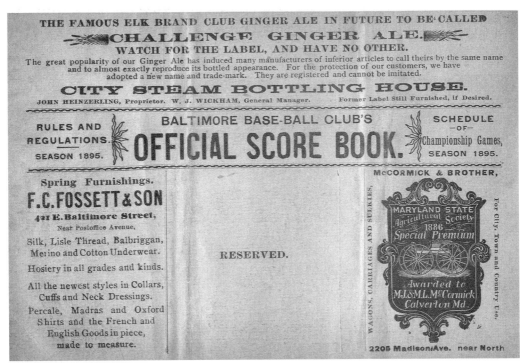

RULES AND
REGULATIONS.
SEASON 1895.

BALTIMORE BASE-BALL CLUB'S
OFFICIAL SCORE BOOK.

SCHEDULE
—OF—
Championship Games,
SEASON 1895.

RESERVED.

ORIOLES SCORECARD, 1895. This 1895 program gives some indication of the increasing marketability of Baltimore baseball to advertisers. Three advertisers are fitted onto one page, with space presumably for a fourth. The Orioles were winners now, and everyone from wagon makers to ginger-ale bottlers was looking for an association with the team. (The Babe Ruth Museum.)

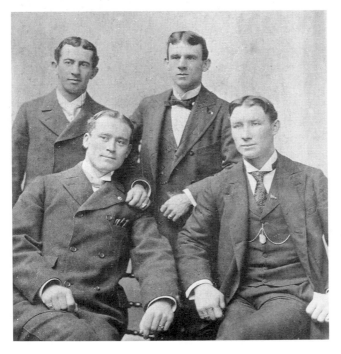

"THE BIG FOUR:" (LEFT TO RIGHT) KEELER, KELLEY, McGRAW, AND JENNINGS. The 1895 Orioles won the National League pennant once again. Many players would contribute to the Orioles successful run in the 1890s, few more than the four pictured here. Shots of baseball players in their finest attire were common to the era, as baseball tried to brand a polished image over the dirt and profanity-filled action that often unfolded on the diamond. (The Babe Ruth Museum.)

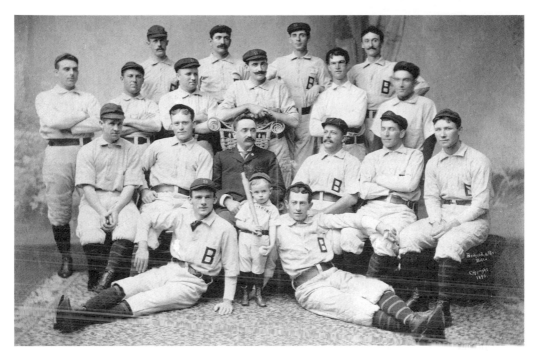

NATIONAL LEAGUE CHAMPIONS, 1895. The 1895 Orioles' record was very similar to that of the 1894 club, and they also took the pennant by three games. One thing the 1895 club had that its predecessor lacked was a bona fide ace. Seated cross-armed second from the right is Bill Hoffer. Hoffer posted 31 wins, second only to Cleveland's Cy Young. (© Corbis.)

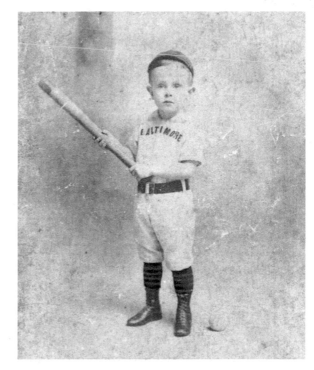

THE BATBOY, 1895. After the successful 1894 campaign, the Orioles added a mascot/batboy. He appeared in the 1895 team photograph, in this solo photograph, and 28 years later with the 1890s Orioles for a group photograph. The caption to the picture still indicated him simply as "batboy." (The Babe Ruth Museum.)

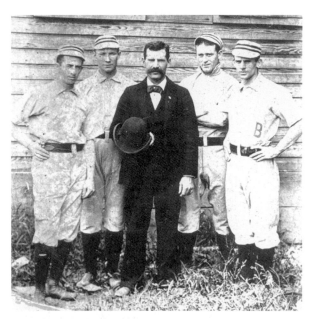

GROUNDSKEEPER THOMAS MURPHY AND THE BIG FOUR, C. 1895. The term "home-field advantage" originated somewhere, and 1890s Baltimore is a sound guess. The Orioles flaunted the line between "crafty" and "cheating" by enlisting the help of groundskeeper Thomas Murphy in manicuring the field to their advantage. Chalked foul lines were strategically thickened to keep Keeler's bunts fair, and Kelley was often accused of fielding the nearest ball hidden in the high outfield grass. (National Baseball Hall of Fame Library, Cooperstown, New York.)

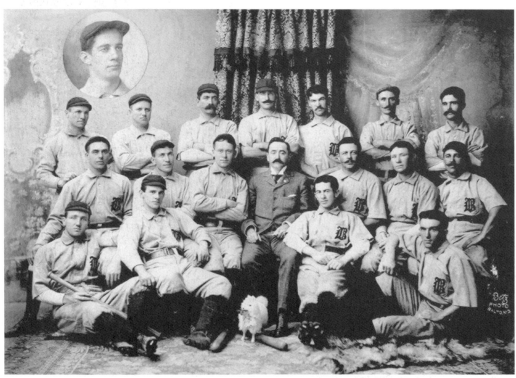

NATIONAL LEAGUE CHAMPIONS, 1896. In 1896, the Orioles won the National League pennant for the third consecutive year. They also claimed the Temple Cup for the first time, a postseason trophy awarded to the winner of a playoff between the league's first- and second-place teams. The Cup series lasted only four seasons, with the Orioles winning two of the four years. (The Babe Ruth Museum.)

LEADING OFF: THE BIG FOUR, 1897.
In this lineup typical of the era, the Big Four lead off this September 1897 contest. Although the scoring is cryptic, it looks like the speedy Keeler stole and scored twice, McGraw singled, stole, and scored, and Jennings stole and scored. Only Kelley was kept quiet. (The Babe Ruth Museum.)

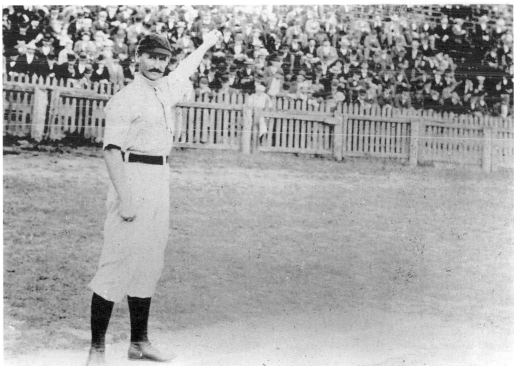

WILLIAM J. "BILL" CLARKE, CATCHER, C. 1897. The Orioles added a mascot in 1895, but unlike his modern counterparts, he was not tasked with energizing the fans. That job fell to backup catcher Bill Clarke, shown here either inciting the fans or showing off their enthusiasm and number. After retirement, Clarke became Princeton's longtime head coach. (The Babe Ruth Museum.)

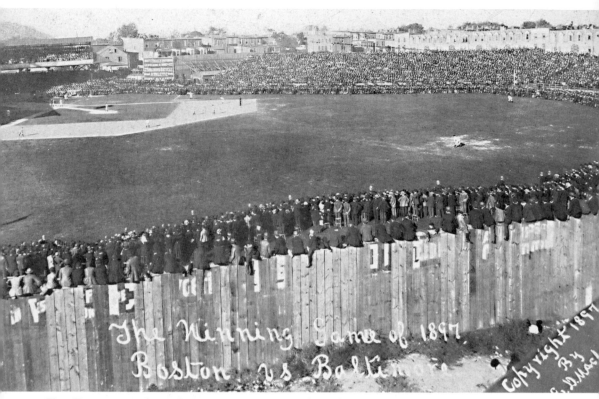

THE END OF THE RUN, SEPTEMBER 27, 1897. Throughout the 1897 season, the Orioles battled for first place with their primary rival, the Boston Beaneaters. The pennant race effectively boiled down to a three-game series between the two in Baltimore in late September. The first game, won by Boston, was countered by an Oriole win in game two. The third and deciding game came before the largest baseball crowd of the 19th century; 30,000–40,000 was the likely total, although with standing room and overflow seating, it was difficult to pinpoint. The largest crowd of the century was also its most disappointed, as Boston posted a 19-10 victory. The Orioles exacted some measure of revenge by beating Boston for the Temple Cup, but interest in the Cup series was failing, and the final game drew only 700 fans. Clearly the pennant was considered the more treasured prize. (National Baseball Hall of Fame Library, Cooperstown, New York.)

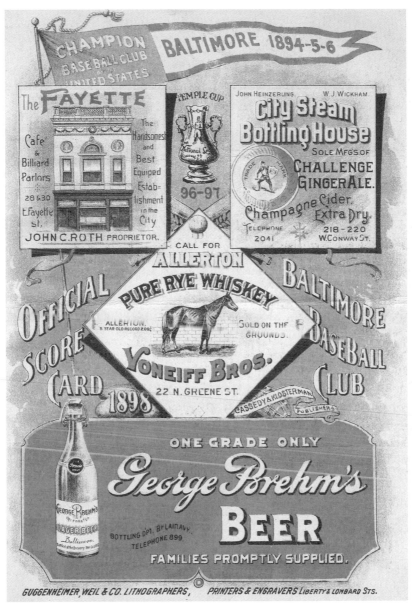

BEER AND WHISKEY LEAGUE VERSION TWO, 1898 ORIOLES PROGRAM. When the National League (founded in 1876) looked out on the baseball world of 1882, it found a new rival: the American Association. Eager to position itself as the genteel fan's league, it belittled the AA as the "Beer and Whiskey League" due to the preponderance of breweries and distilleries that owned the new league's franchises. From a business perspective, it made good sense for a brewery to own a baseball team; on game days, it had a captive market of thousands of customers at its ballpark. The Baltimore franchise was owned by Eagle Brewery—one of 40 in the city—and it quickly distinguished itself from the other 39 through its team. Ironically, by 1898, the program of the National League's most successful franchise had two items prominently featured on its full-color cover: beer and whiskey. (The Babe Ruth Museum.)

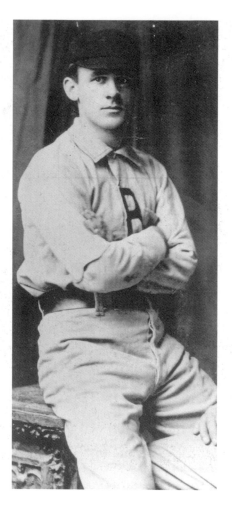

THE HOLDOUT, JOHN MCGRAW, C. 1899. The late 1890s gave rise to "syndicate baseball," whereby an owner of one team could also hold shares of another. The result was that one team was often stripped of its best talent to bolster an owner's primary franchise. So it happened to Baltimore; its best players were sent packing to Brooklyn in 1899. John McGraw refused to go. (National Baseball Hall of Fame Library, Cooperstown, New York.)

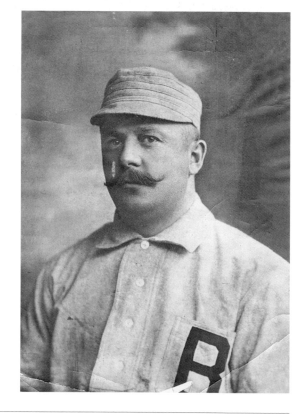

THE HOLDOUT'S BASEBALL AND BUSINESS PARTNER. Wilbert Robinson also refused to head to Brooklyn. With a history in Baltimore dating back to the American Association, it must have been difficult to watch as the second-place 1898 Orioles were scrapped for the 10th-place Brooklyn team, who had a larger market. Robinson was also a successful Baltimore business partner with McGraw off the field and held fast. (National Baseball Hall of Fame Library, Cooperstown, New York.)

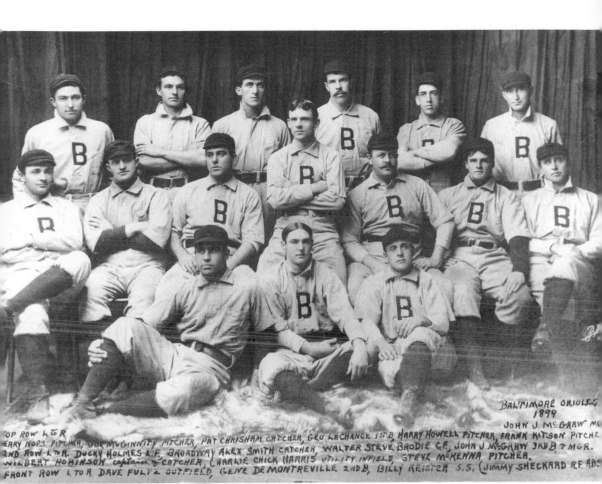

BALTIMORE ORIOLES
1899
JOHN J. McGRAW M
'OP ROW L TO R
ERRY NOPS PITCHER, JOE McGINNITY PITCHER, PAT CHRISHAM CATCHER, GEO LACHANCE 1ST B, HARRY HOWELL PITCHER, FRANK KITSON PITCHE
2ND ROW L TO R. DUCKY HOLMES L.F. BROADWAY ALEX SMITH CATCHER, WALTER STEVE BRODIE C.F., JOHN J McGRAW 3RD B, & MGR.
WILBERT ROBINSON captain & CATCHER, CHARLIE CHICK HARRIS UTILITY INFIELD, STEVE McKENNA PITCHER,
FRONT ROW L TO R. DAVE FULTZ OUTFIELD, GENE DE MONTREVILLE 2ND B, BILLY KEISTER S.S. (JIMMY SHECKARD R.F. ABS

BALTIMORE'S PRIDE, THE 1899 ORIOLES. Although Brooklyn took the 1899 pennant, the most remarkable team that year remained in Baltimore. New manager McGraw, working with a skeleton crew of Old Oriole talent, finished 24 games above .500. A similarly stripped Cleveland team (its best talent sent to bolster St. Louis) won just 20 games and finished a harrowing 84 games out of first. Remarkably McGraw's Orioles even finished higher than St. Louis. McGraw batted a career-high .390. Rookie and future Hall of Famer Joe McGinnity rang up 28 wins. On the season, Baltimore outdrew Brooklyn, as the fans turned out in volume to see McGraw's Orioles. There would be no follow-up act, however, as the National League consolidated to eight teams in 1900, and the Baltimore franchise was eliminated. (The Babe Ruth Museum.)

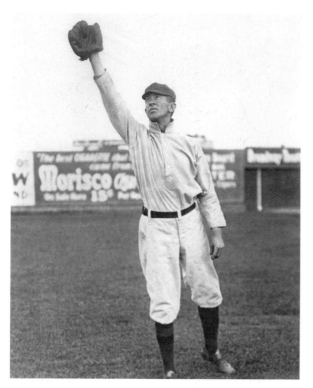

RIGHT FIELDER WILLIE KEELER, NEW YORK HIGHLANDERS. The 1890s Orioles slowly broke apart, as all teams gradually do. Willie Keeler, shown here as a New York Highlander (better known today as the New York Yankees), first went to Brooklyn in 1899 and then eventually migrated over to the American League (AL) in 1903 to star for the new franchise. (National Baseball Hall of Fame Library, Cooperstown, New York.)

KEELER AND MCGRAW, c. 1910. In the last season of his 19-year Hall of Fame career, Willie Keeler played briefly for the National League's New York Giants. His manager was old Oriole teammate John McGraw. Both were notorious for their poker-faced portraits, and in this picture one can nearly hear the photographer coaxing a smile from them as they resisted; Keeler slipped. (Getty Images.)

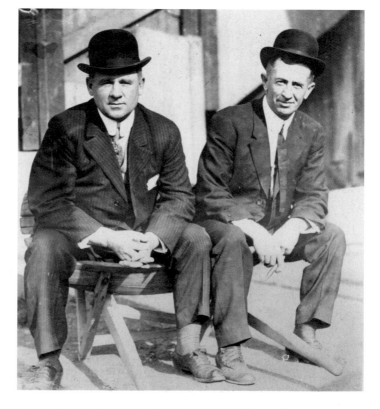

MANAGERS MCGRAW AND ROBINSON.
After Baltimore, McGraw and Wilbert
Robinson later enjoyed long tenures as
managers of New York's National League
teams. Robinson, prior to leading the
Dodgers (known for a period as the Robins),
was briefly a coach with McGraw's Giants.
Their relationship was strained over a
missed sign in the 1913 World Series,
and Robinson left for Brooklyn. McGraw
managed the Giants for 31 years, and
"Uncle Robbie" led Brooklyn for 18.

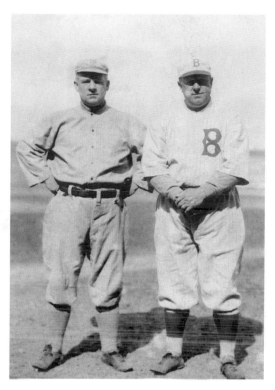

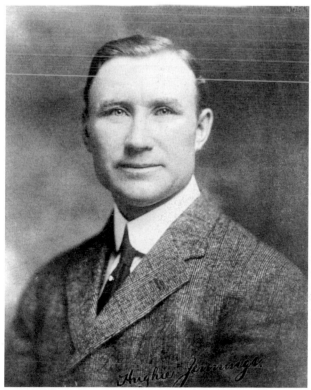

MANAGER HUGHIE JENNINGS.
Jennings followed his teammates
into the coaching ranks. He
coached the initial Eastern League
Orioles in 1903 and spent four
seasons there before returning to
the majors in 1907 as the manager
of the Detroit Tigers. He won
pennants in his first three seasons
and managed the team for 14 years
as part of a Hall of Fame career.
(National Baseball Hall of Fame
Library, Cooperstown, New York.)

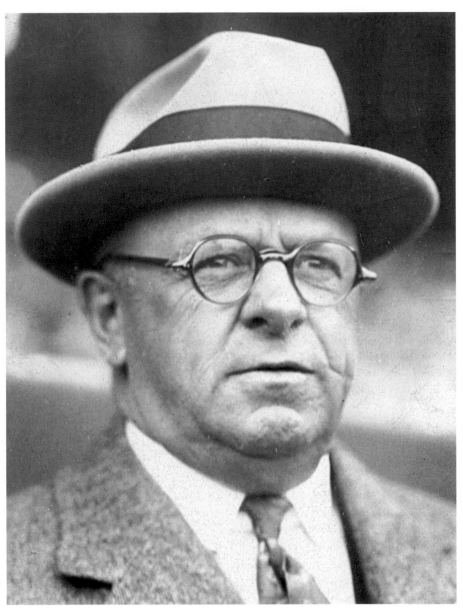

THE DIGNIFIED ROBINSON, C. 1932. Wilbert Robinson deserves a last look before leaving behind the Old Orioles. An excellent ballplayer, he developed a quirky reputation as a manager. As a player, he was a cornerstone behind the plate for the 1894–1896 champions. As a manager, he was loved by his players, and in 1915, he agreed to their challenge to catch a baseball dropped from a plane. The baseball proved to be a grapefruit, and when it splattered all over his chest Robinson mistook it for blood and thought that he'd just been killed. He also once benched a player because he couldn't spell his name on the lineup card. Ultimately, the talented and quirky Uncle Robbie came home to Baltimore; he is buried at the city's New Cathedral Cemetery, as were non-native Baltimoreans Hanlon, Kelley, and McGraw. (National Baseball Hall of Fame Library, Cooperstown, New York.)

FOUR LEAGUES

1900–1915

The majors returned in 1901 after a brief absence. Ban Johnson's new American League placed a franchise in Baltimore with Robinson and McGraw taking the helm. Their stay in Baltimore was short. McGraw feuded incessantly with Johnson over his aggressive style of managing and play. Johnson wanted to distance his new American League from the rough-and-tumble image of the National League. Typical of their relationship was an incident in which McGraw (again a player-manager with the new AL Orioles) was hit by a pitch in five consecutive at-bats in a single game. When he took umbrage with the umpire he was ejected. Upon appeal, Johnson backed the umpire, and McGraw was briefly suspended.

It was but one of many disagreements, and in June 1902, Johnson suspended McGraw indefinitely. McGraw, eyeing escape from Johnson's rule and also the chance to direct a team on a larger stage, jumped ship to the NL's New York Giants. Johnson then had the league take direction of the Orioles. At the close of the 1902 season, Baltimore was back out of the majors, as Ban completed his long-rumored plan to move the franchise to New York.

In 1903, the Eastern League relocated a franchise to Baltimore, where it was put under Hughie Jennings and Robinson. The team took up residence at lightly used American League Park, former home of the now-departed Orioles.

As Jennings and Robinson gradually made their way back to the majors as managers, another savvy ballplayer-turned-manager stepped in behind them. John Joseph "Jack" Dunn, a veteran of the 1901 AL Orioles, began managing the Eastern League Orioles in 1907 and eventually became the majority owner of the club. Dunn won the pennant in 1908 and would stabilize the franchise and the city's baseball fortunes for many years. His greatest hurdle to long-term success came relatively early in his tenure, as he struggled to outlast the upstart Federal League's Baltimore Terrapins in 1914.

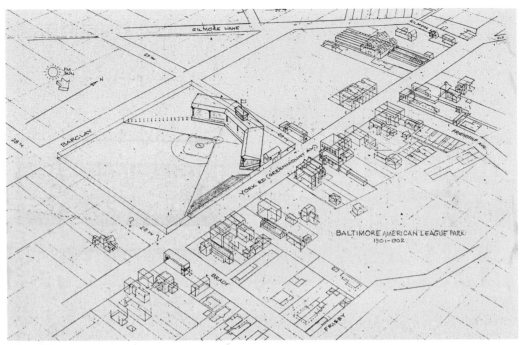

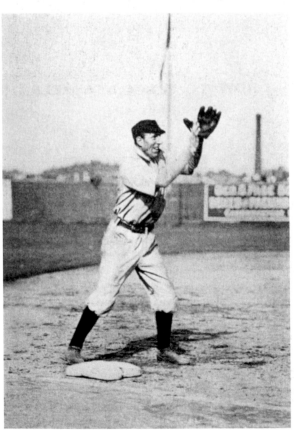

SKETCH OF THE BALTIMORE AMERICAN LEAGUE PARK. Union Park, the former home of the NL Orioles, was still under NL control in 1901 and off-limits to the new Orioles. They then built their own park, shown here in a later sketching, that was modest but ample. After the AL Orioles departed, it became home to the Eastern League Orioles. (National Baseball Hall of Fame Library, Cooperstown, New York.)

JACK DUNN, NEW YORK GIANTS, c. 1904. Third baseman Jack Dunn, seen here with the Giants, played eight seasons in the majors. His career highlight was a 23-win season as a pitcher in 1899 for a Brooklyn team bolstered with Baltimore talent. In 1907, he became the manager of the Eastern League's Orioles and stayed at the helm through the 1928 season. (Transcendental Graphics.)

FOUR LEAGUES: 1900–1915

MERLE "DOC" ADKINS BASEBALL CARD, C. 1909. Merle "Doc" Adkins pitched in only six games in the majors but was a longtime standout for the minor-league Orioles and a member of the original 1903 team. Adkins won 20 or more games four times, including a career-high 29 for the 1908 pennant winners. In 1907, Doc earned his nickname, and medical degree, from Johns Hopkins.

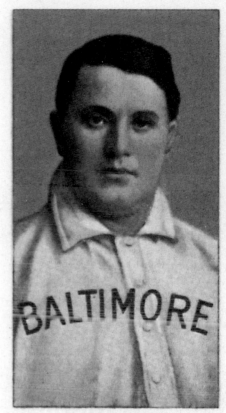

ADKINS, BALTIMORE

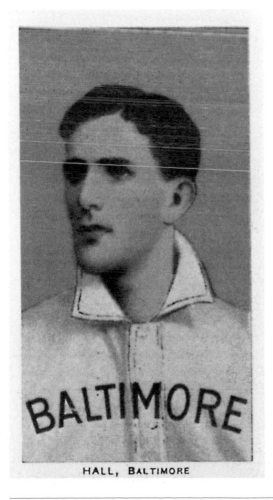

HALL, BALTIMORE

BOB HALL BASEBALL CARD, C. 1909. Native Baltimorean Bob Hall was one of many non-stars who contributed steadily to the early Eastern League Orioles. An average hitter, his strength was his versatility. In five years with the Orioles, he logged 327 games at third base, 102 in the outfield, 67 at second base, and 51 at shortstop. Dunn used Hall to fill virtually any gap in his fielding lineup.

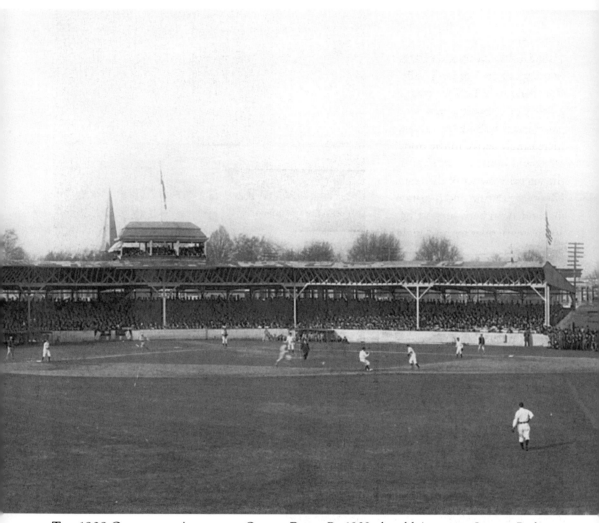

THE 1909 ORIOLES IN ACTION AT ORIOLE PARK. By 1909, the old American League Park was firmly established as the Eastern League Orioles' home and took on the inevitable Baltimore ballpark name of that era: Oriole Park. This Oriole Park featured a straightforward, one-tiered design. This photograph depicts a full house and a thriving Baltimore baseball scene. The dark-capped player near third is likely Bob Hall, as he manned the position for 136 games that year. A double play is unfolding, and perhaps a moment later in time, the fans will rise from their seats and roar their approval for their Eastern League defending champs.

JACK DUNN, FIELD AND FRONT OFFICE. When Dunn arrived in Baltimore in 1907, he was a player-manager, and as his playing diminished, he became increasingly active in the front office and would eventually be the majority owner of the team. His ability to find and integrate local talent in both supporting and primary roles for his Orioles became legendary. Countless local players plugged brief gaps in the lineup, and players came from across Maryland, with the better-known including Jack Bentley, Lefty Grove, and Babe Ruth. (Both the National Baseball Hall of Fame Library, Cooperstown, New York.)

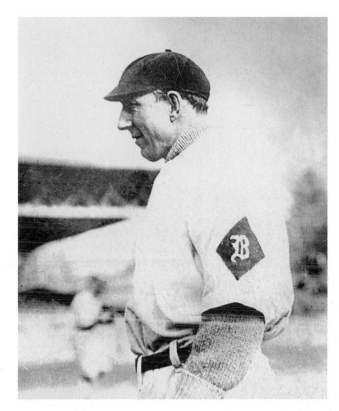

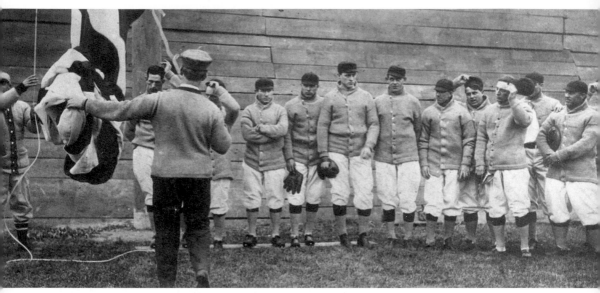

HATS ON OR OFF? OPENING DAY, 1910. This Oriole team is undecided as to whether or not it's time to remove their caps for the unfurling of the flag on Opening Day in 1910. The now-familiar Hall, his back to the pole and second from left, has his off but looks uncertain. The player to the right of him follows his cue, while Jimmy Catiz, one further down the line, clearly has no immediate plans for removing his. A glowering Dunn (sixth from the right) has Hall fixed in his sights and his own cap firmly on, while the amiable Doc Adkins (just to the right of Dunn) looks like he's voicing his intentions as he removes his own cap. (Hearst Communications, Inc.)

FRITZ MAISEL, THE "CATONSVILLE FLASH." Maisel joined the Orioles in 1911 from Catonsville, just southwest of the city. Maisel would stay less than three seasons with the now–International League Orioles before heading to the major-league New York Yankees in late 1913. There he would become a fixture for several seasons at third, stealing 74 bases in 1914 to set a Yankee record that would hold for over 50 years. By 1919, he was back with the Orioles, and his best baseball would be played with the city's greatest baseball dynasty. (At right, Baltimore County Public Library; below, the National Baseball Hall of Fame Library, Cooperstown, New York.)

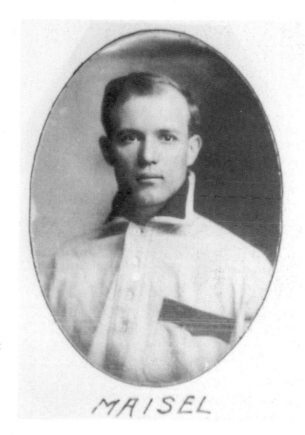

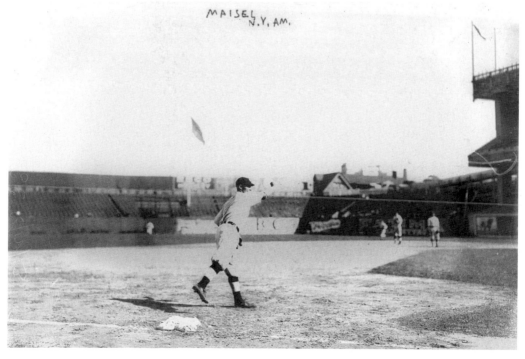

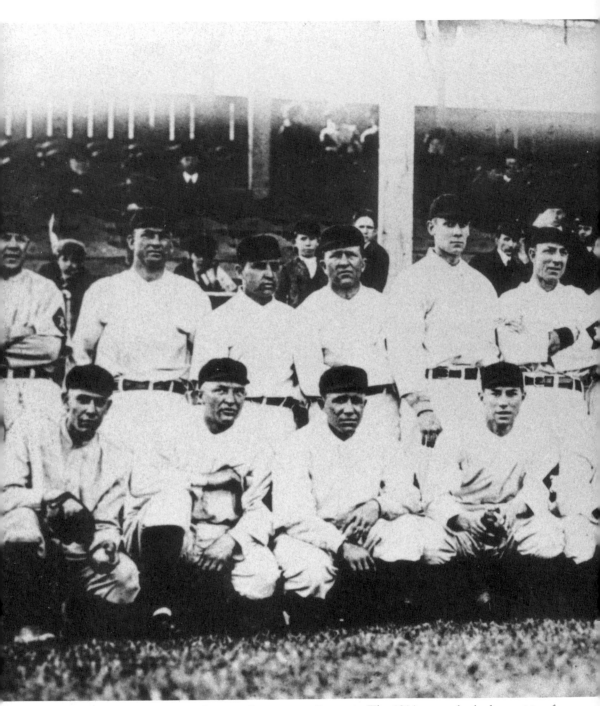

THE 1914 INTERNATIONAL LEAGUE BALTIMORE ORIOLES. The 1914 season looked promising for the Orioles. Jack Dunn signed George Herman "Babe" Ruth (fifth from left, first row) from St. Mary's Industrial School for Boys in Baltimore in the off-season, and he proved a phenomenon during spring training. Nearly 70 games into the season, they were 47-22 and 5½ games up in first place. The young Ruth was 14-6 as a pitcher. The problem wasn't on the field—it was across

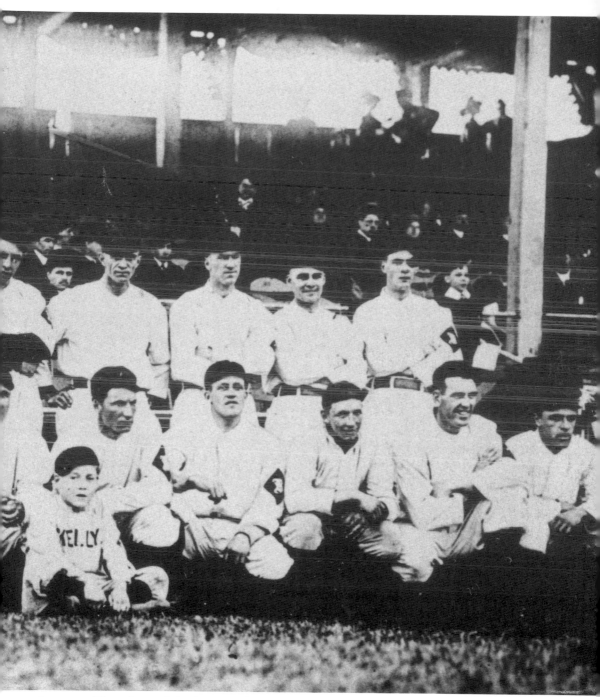

the street. There loomed the larger and newer Terrapin Park, home to the Baltimore Terrapins of the Federal League, a new major league that began play that season. Dunn had the better club but not the "major" appeal, and the Orioles played to almost completely empty stadiums. He was forced to sell Ruth in July. (National Baseball Hall of Fame Library, Cooperstown, New York.)

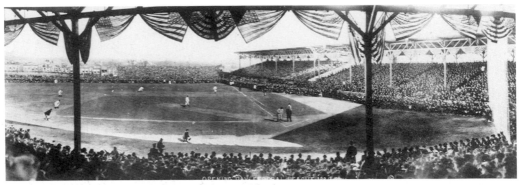

OPENING DAY, TERRAPIN PARK, APRIL 13, 1914. The Federal League's "Terps" hosted the first game in league history. It was the major leagues again for Baltimore, and the crowds responded with 30,000 filling the seats of the new park. On April 23, Ruth's pitching debut for the Orioles was witnessed by 200. (The Babe Ruth Museum.)

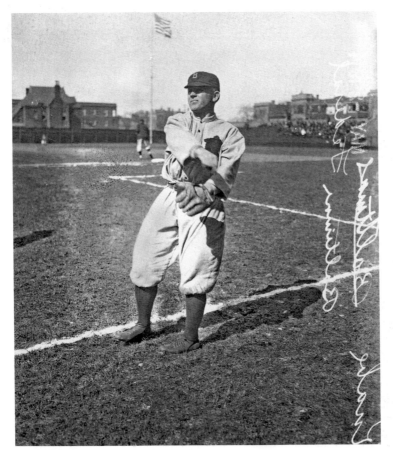

OTTO KNABE, TERRAPINS MANAGER, MAY 1914. Otto Knabe left the National League's Phillies to take charge of the Terrapins and is seen here warming up before a game. Behind him is the just-completed Weeghman Park, the crowned jewel of the Federal League's new parks and built for the League's Chicago Whales. It is better known today as Wrigley Field. (The Chicago History Museum.)

JIMMY WALSH, BALTIMORE TERRAPINS, MAY 1914. Third baseman Jimmy Walsh was one of the few Terrapins to play consistently from 1914 to 1915, as he batted over .300 both years. Walsh was one of several Phillies to follow Knabe's lead and jump to the Terrapins. (The Chicago History Museum.)

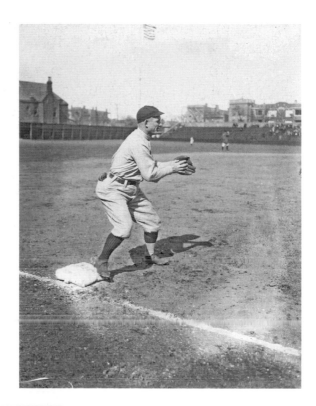

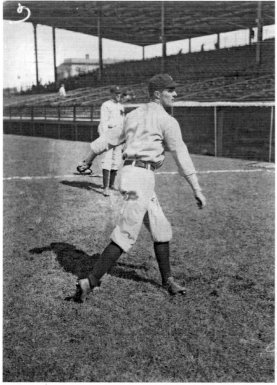

JACK RIDGWAY, BALTIMORE TERRAPINS, MAY 1914. Along with veterans, a handful of "Moonlight Grahams" (players who made only a passing appearance in the majors) manned the Terrapins roster. One was Jack Ridgway, 0-1 as a major-league pitcher in four career games. Here Ridgway follows through with a flourish while warming up in Chicago. (The Chicago History Museum.)

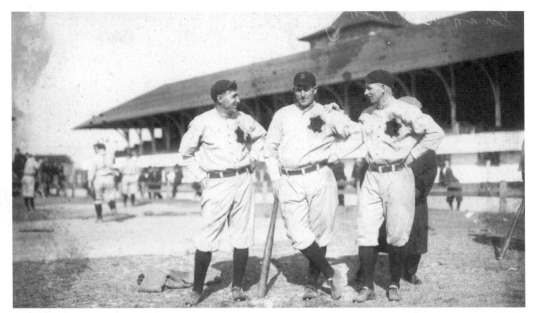

BALTIMORE TERRAPINS, FAYETTEVILLE, NORTH CAROLINA, SPRING 1915. From left to right, Benny Meyer, Harry Swacina, and Enos Kirkpatrick enjoy the warm North Carolina sun during their spring training with the Terrapins in 1915 at Fayetteville's Cape Fear Fairgrounds. They have reason to be happy: all are returnees from the 1914 club that went 84-70 and finished third, just under five games out of first place. (The Maryland Historical Society.)

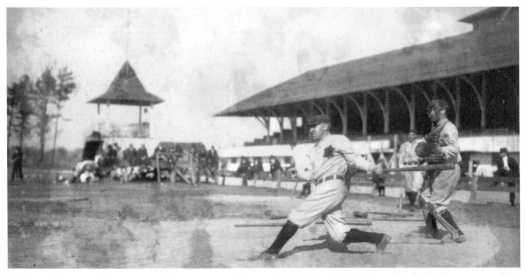

BENNY MEYER, BALTIMORE TERRAPINS, SPRING 1915. In 1914, Meyer had the best year of his brief career, batting .304 and appearing in 136 games. His fortunes appeared on the rise, along with the Terrapins, in spring of 1915. Here he takes batting practice at the Cape Fear Fairgrounds in a unique baseball setting with a horse track and grandstand as the backdrop. From the same spot a year before, rookie Babe Ruth launched the longest home run in Fayetteville's history. (The Maryland Historical Society.)

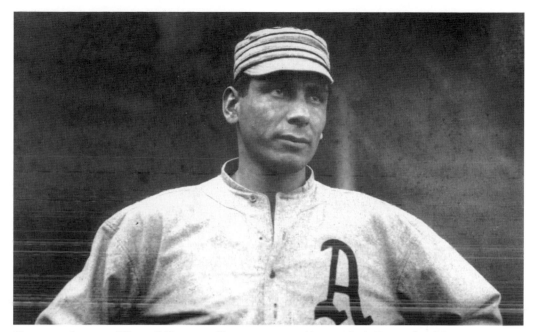

CHARLES ALBERT "CHIEF" BENDER, PHILADELPHIA A'S, C. 1914. So much of the optimism in the spring of 1915 surrounded the addition of one man, pitcher Chief Bender. The year before, Bender went 17-3 for the A's for the highest winning percentage in the American League and was the type of player a franchise could be built around. (National Baseball Hall of Fame Library, Cooperstown, New York.)

CHIEF BENDER, CASTLEBERG'S ADVERTISEMENT, SPRING 1915. Once the majors arrived in Baltimore, advertisers lined up to associate with them. The biggest of all the draws, Bender, joined the team in the spring of 1915, and he quickly supplemented his Terrapins income with this advertisement. (The Babe Ruth Museum.)

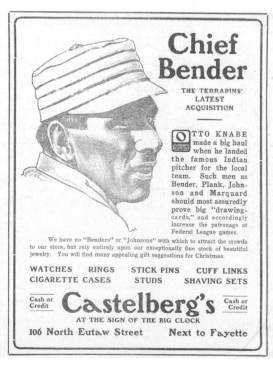

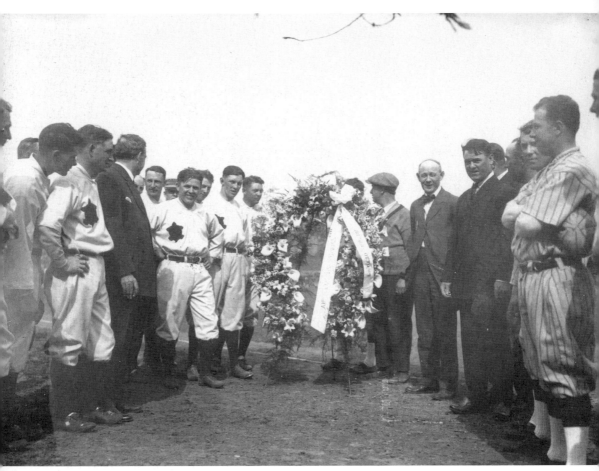

APPRECIATING OTTO, OPENING DAY, 1915. Quickly mimicking the routines of the older major leagues, the Federal League offered its players its own, prematurely nostalgic, player-appreciation days. Here Otto Knabe, beginning only his second year as a manager, is saluted by his "Friends From Philadelphia." The still-young Knabe (hands on hips, facing the camera) looks genuinely grateful. The Newark Peppers, the Terrapins' opponents for the day and playing in their first game representing Newark, look eager to get on with the game. (The Maryland Historical Society.)

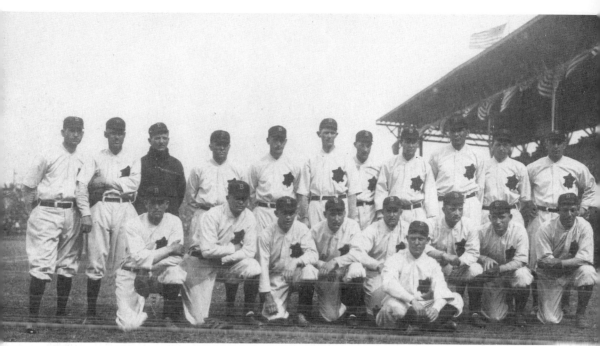

THE 1915 BALTIMORE TERRAPINS. For the second straight season, the Terrapins opened at home. Their guests, the Peppers, were a refitted version of the Indianapolis franchise that won the Federal League pennant in 1914 and then was moved east. It was no secret that the Feds planned to take the Peppers over into New York the next season if things went well. They didn't. The league barely made it through the season, and the Terrapins were an awful 47-107. Hall of Famer Chief Bender had the worst year of his career and finished 4-16. The Federal League disbanded at season's end, and every franchise received some compensation for their team from Organized Baseball except Baltimore. It was assumed that Dunn's International League Orioles would pick up the remaining Terps. Dunn's response was, "Nobody's horning into my club." Especially "nobody" that nearly drove him out of business. Baltimore's Federal League owners sued Organized Baseball and lost, with the Supreme Court essentially offering Organized Baseball an anti-trust exemption. (The Babe Ruth Museum.)

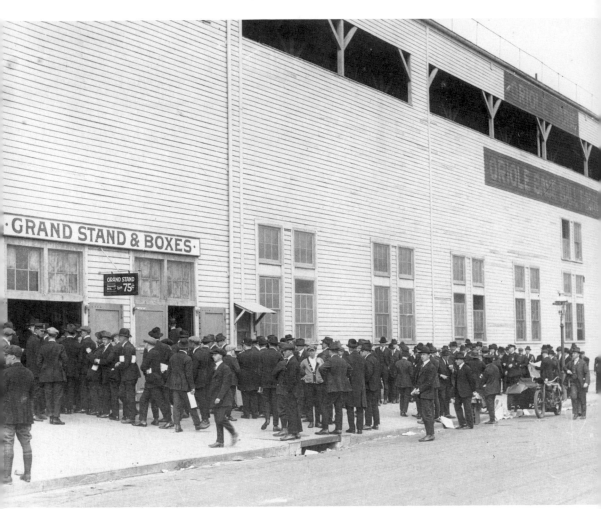

ORIOLE PARK EXTERIOR, C. 1917. Jack Dunn, forced to Richmond for the 1915 season by competition from the Federal League, was back with a new franchise in Baltimore by 1916 and bought the now-empty Terrapin Park. Built in early 1914 for $90,000, Dunn purchased it for $25,000 two seasons later. It was Dunn's second straight former-major-league ballpark for his minor-league team, and it was larger and grander than the first. It was not long before Dunn would have a team befitting his fine new park. (Hearst Communications, Inc.)

3

ST. MARY'S WONDER

BABE RUTH

George Herman "Babe" Ruth was born in 1895 in a brick row house just blocks from Baltimore's harbor. Little is known of his youngest years, but in June, it is known he was taken to live at a boy's school in southwest Baltimore. The official name for the school was St. Mary's Industrial School for Orphans, Delinquent, Incorrigible, and Wayward Boys. The Babe was not an orphan.

St. Mary's taught trade skills, academics, and obedience. The school's Xaverian Brothers' religious instruction was of the working variety, assimilating their ongoing spiritual message into the daily tasks that kept the "incorrigibles" busy and the school running. They also taught baseball.

In 1909, there were 28 uniformed teams at the school, and Babe played as many as 200 games a summer. His greatest influence at the school was the towering Brother Matthias. Six-feet, six-inches tall and nearly 300 pounds, he was the school's primary disciplinarian, but on special Saturday evenings discipline yielded to baseball, and he would treat the students to a spectacle that few would ever forget.

Brother Matthias would take his bat, adjourn to the school's massive courtyard, and hit one arching blast after another high into the skies above St. Mary's. The crowd of enthralled children would scramble to recover the prized balls. Like a Fourth of July firework display, each session ended with a grand finale of baseballs that rained down amongst the boys. For one boy, who spent the better part of 12 years at a home he never chose (the average stay was two), these moments were amongst his happiest at the school.

Eventually tales of Babe's own baseball prowess transcended the walls of St. Mary's. On February 14, 1914, Jack Dunn arrived to check on the prodigy. The cold precluded a workout, so it was on his sound instinct and the glowing praise of Brother Gilbert at nearby St. Joseph's College that Dunn signed Ruth to a contract. The Babe was a Baltimore Oriole, albeit briefly. Within six months, financial pressures brought on by the Baltimore Terrapins forced Dunn to reluctantly sell Ruth, and within six seasons, Jack Dunn's "Babe" would be the greatest baseball player in the world.

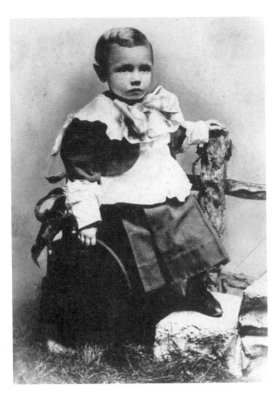

GEORGE HERMAN RUTH, C. 1897. George Herman Ruth was born on February 6, 1895, to George and Katie Ruth at Katie's parents' home on Emory Street in the Pigtown neighborhood of Baltimore. George Sr. was a tavern owner, and little is known of Katie. Ruth had one younger sister, Mamie, who also survived infancy, and six other siblings who did not. (National Baseball Hall of Fame Library, Cooperstown, New York.)

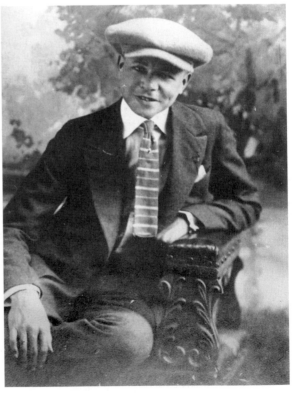

THE YOUNG BABE IN HIS FINEST, C. 1906. The Ruths lived a hard life, replete with all the manifest problems of poor, urban America at the beginning of the 20th century. Sending the Babe to St. Mary's may have been a compassionate decision or more likely the actions of parents grown weary of both hardship and a difficult child. Virtually no oral or written narrative exists to discern the true circumstances. (National Baseball Hall of Fame Library, Cooperstown, New York.)

ST. MARY'S WONDER: BABE RUTH

IN THE FIELD AT ST. MARY'S, AGE 16. A teenaged Babe, at right, stands ready in the field at St. Mary's. In his career, the Babe was often cited for always knowing where to throw the ball in key game situations. The term often used to describe it was "instinctive," implying an innate skill with which the Babe was fortunately born. This diminishes the thousands of hours of games and practices in the courtyard at St. Mary's where he learned just where to throw the ball and when. He also learned how to hit. In the image below, the left-handed Babe plays catcher with a right-handed catcher's glove yet seems as happy as ever simply to be playing baseball. (At right, Enoch Pratt Free Library; below, the National Baseball Hall of Fame Library, Cooperstown, New York.)

BROTHER MATTHIAS BOUTLIER. The 1890s Orioles perfected the bunt, the hit-and-run, and the slap hit. They also invented the Baltimore Chop, a play in which the ball was either struck down directly onto the plate or into the hard-packed dirt in front of it and, during the ensuing bounce, Keeler, McGraw, and company were well onto their way to first for a single. Brother Matthias hailed from Nova Scotia, and his variety of hitting was the antithesis of Old Oriole baseball. He favored big booming shots high into the sky from an uppercut swing that would never have produced a Baltimore Chop base hit. Ruth developed the same swing and the same propensity for the long ball as Brother Matthias. (National Baseball Hall of Fame Library, Cooperstown, New York.)

ST. MARY'S WONDER: BABE RUTH

MAISEL HELPS LAND THE BABE. Mystery surrounds the Babe's signing to a professional contract in February 1914. One version includes Jack Dunn, Brother Gilbert of St. Joseph's, and Yankee Fritz Maisel arriving at St. Mary's and working through a contract with Brother Matthias. Maisel was clearly brought along to show the Babe that signing with Dunn could lead to the majors, just as it had for him. No one knew then how appropriate a choice a Yankee would prove. (The Catonsville Room, the Catonsville Library.)

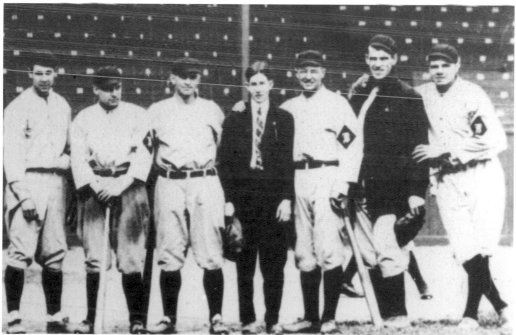

EGAN AND RUTH, 1914. Isolated to the far right of a team photograph is the 19-year-old Babe leaning against catcher Ben Egan. By July, Egan, Babe Ruth, and recent Guilford College graduate Ernie Shore were dealt to the Red Sox for cash as Dunn struggled to keep the Orioles afloat financially. (Transcendental Graphics.)

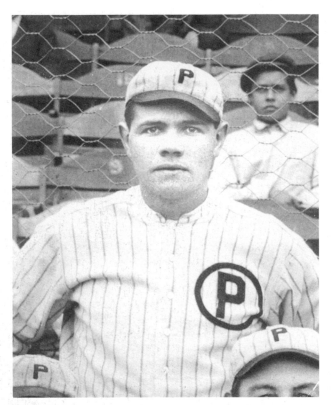

BABE RUTH, PROVIDENCE GRAYS, 1914. The Babe's first stop after being dealt to the Red Sox was Boston. He arrived there on the morning of July 11, pitched in his first major-league game that afternoon, and notched his first win. Despite pitching well, Ernie Shore beat him out for the final spot on the Sox roster and by August the Babe was in Providence. (National Baseball Hall of Fame Library, Cooperstown, New York.)

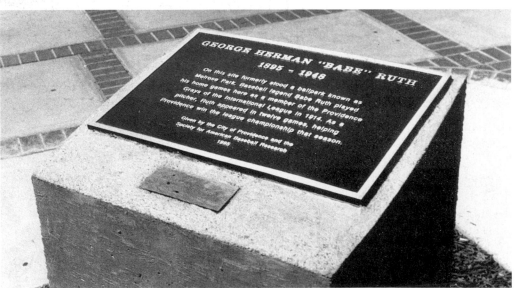

BABE RUTH PITCHED HERE. Not unlike the prolific "George Washington Slept Here" notations that dot the American landscape, there are a substantial number of plaques denoting variations on "Babe Ruth Hit Here." This one in Providence, Rhode Island, may be unique in foregoing any mention of his hitting feats in lieu of his pitching contributions to the minor-league Grays. (National Baseball Hall of Fame Library, Cooperstown, New York.)

ST. MARY'S WONDER: BABE RUTH

GEORGE JUNIOR AND SENIOR, RUTH FAMILY BAR. This shot of a young Babe Ruth and his father sheds little insight into the relationship between the two. To the far right, George Sr. looks up for the photograph. If he's proud of his budding young star it is not reflected in his expression. The Babe's look is less severe but also discloses little. Following his rookie season in 1914, Ruth returned to Baltimore and was married to waitress Helen Woodford in Ellicott City, Maryland. He lived above the family bar and spent that winter and several subsequent off-seasons in Baltimore. His mother died earlier in 1912 of tuberculosis and "exhaustion." In 1918, George Sr. was killed in a brawl outside the family bar. After his father's death, the Babe no longer returned to Baltimore to live in the off-season. (Transcendental Graphics.)

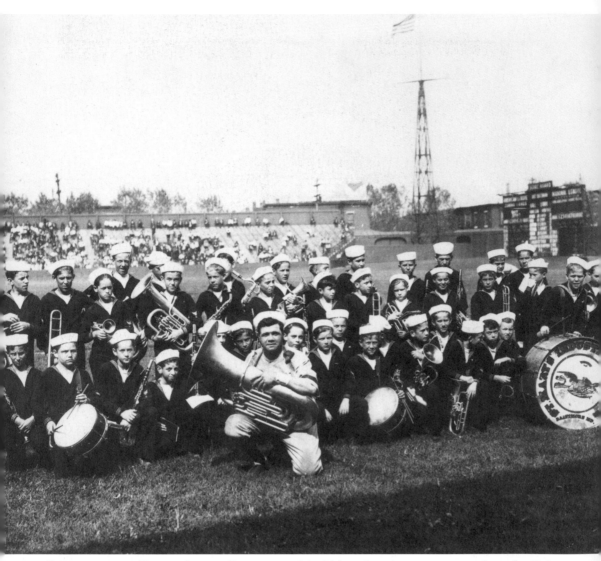

LEADER OF THE BAND, ORIOLE PARK, C. 1920. Although never returning to live, the Babe did visit Baltimore regularly. Here he is seen at a fund-raiser at Oriole Park as the front man for the St. Mary's Industrial School Band. The school suffered a major fire in 1919, and the Babe traveled to the city to help with rebuilding efforts. The Babe never forgot the school, or his own experience as a boy, and he spent a lifetime genuinely reaching out to children. To many children in hardship, he was the embodiment of their highest hopes in places and situations where hopes rarely ran high. During one western barnstorming tour, he hit 1,000 autographed baseballs to 10,000 Los Angeles schoolboys and nearly fell off a grandstand roof doing so. It was the greatest of tributes to the mighty Matthias. (Transcendental Graphics.)

ST. MARY'S WONDER: BABE RUTH

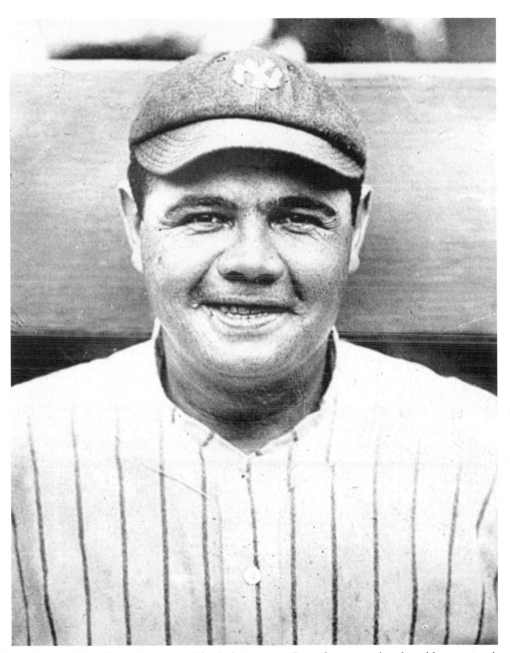

BABE RUTH, NEW YORK YANKEE. The Babe's stay in Providence was brief, and he returned to Boston to help the Sox win pennants and the World Series in 1915, 1916, and 1918 with his efforts at the plate and on the hill. By early 1920, in ground well covered, Red Sox owner Harry Frazee sold Babe Ruth to the New York Yankees. The short version is that he funded the Broadway play *No, No, Nanette* with the sale; the longer story is that he was a New Yorker entwined with Yankees' owners Colonels Tillinghast Huston and Jacob Ruppert in a number of business dealings, and the Ruth sale was but one of a number of transactions. (National Baseball Hall of Fame Library, Cooperstown, New York.)

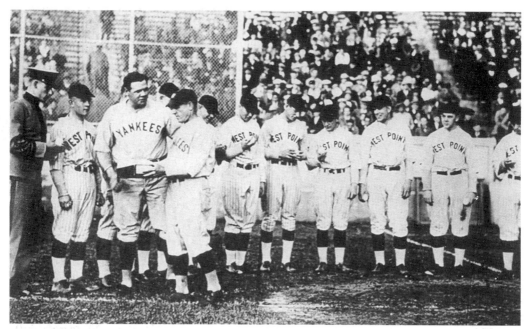

WEST POINT EXHIBITION GAME. The Babe would win seven pennants and four World Series with the Yankees over the next 15 seasons and break countless records. A less-quoted accomplishment was simply how often he played. His 200-game summers at St. Mary's stayed with him. The Babe barnstormed and played in more exhibition games than virtually anyone. Here he entertains his opponents at West Point in May 1927. (National Baseball Hall of Fame Library, Cooperstown, New York.)

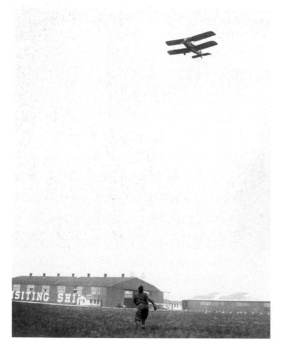

THE BABE BESTS WILBERT, MITCHEL FIELD, 1926. In July 1926, the Babe attempted to become the first man to catch a baseball dropped from a plane. Wilbert Robinson had failed in his aforementioned 1915 effort when the baseball proved a grapefruit. At Mitchel Field, New York, the Babe went one for three, catching the third—and to the Yankees' relief not killing himself in the process. (National Baseball Hall of Fame Library, Cooperstown, New York.)

ST. MARY'S WONDER: BABE RUTH

PROFESSOR RUTH. The Babe was certainly smart enough to poke fun at his modest intellect, as seen in this publicity shot. His intelligence was sometimes unfairly denigrated to imbecilic in the press, particularly in opposing AL cities. Poet Carl Sandburg "interviewed" the Babe in 1928 for the *Chicago Daily News* with that specific intent. It fell flat, and the *News* presumably never had the two square off in a home run contest following the interview. (National Baseball Hall of Fame Library, Cooperstown, New York.)

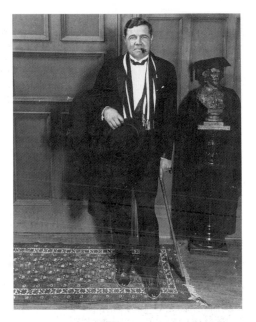

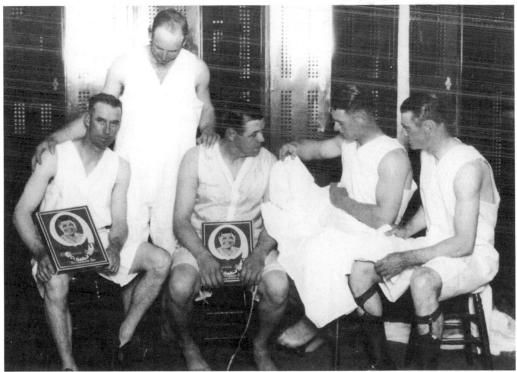

THE BABE AND LOU BARE SOME, EARLY 1930S. With the arrival of Lou Gehrig in 1923, the Yankees had two of the most potent hitters in baseball for a decade to follow. They also had two of its most marketable. Here the Babe and Lou, second from the right, put their marketing might behind selling the Babe's line of underwear. (National Baseball Hall of Fame Library, Cooperstown, New York.)

Nova Scotia Hunting Trip, 1936. In 1935, the Babe spent a final disappointing year with the Boston Braves before retiring as an active player. He desired a head coaching position following his retirement, but it never materialized. His popularity with the public, especially children, would remain high well beyond his playing days. (Enoch Pratt Free Library.)

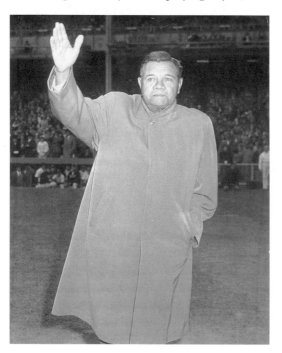

The Long Wave Good-Bye, 1946–1948. The Babe slowly lost a battle to cancer that began in late 1946 and ended with his death on August 16, 1948. During 1947 and 1948, as he grew increasingly ill, he still made appearances before appreciative crowds who flocked to see him. April 27, 1947, was Babe Ruth Day throughout baseball, and the Babe appeared at Yankee Stadium before 58,000 adoring fans. (National Baseball Hall of Fame Library, Cooperstown, New York.)

ST. MARY'S WONDER: BABE RUTH

4

THE INTERNATIONAL
LEAGUE O'S

1916–1928

From the 1916 season through 1953, Baltimore was strictly a minor-league baseball town. Located between Washington and Boston, it still saw its fair share of major-league action, as teams traveling either north from spring training or between American League cities would stop in for an exhibition game.

The International League Orioles often sent their major-league guests packing with a loss. From 1919 to 1925, the loss sometimes took the form of a trouncing. In a 1924 exhibition, Lefty Grove fanned 14 Philadelphia A's. He also struck out the Babe 9 out of the 11 times he faced him in exhibition games as an Oriole. It was during those years that the Orioles rattled off seven straight International League pennants, a streak unrivaled in Baltimore's professional baseball history.

Jack Dunn held fast to his brightest stars until they reached their market peak. After his premature death in 1928, a handful of his Oriole alumni, including Grove, boosted Connie Mack's Philadelphia A's to their greatest heights as they won both the 1929 and 1930 World Series and narrowly missed winning a third in 1931.

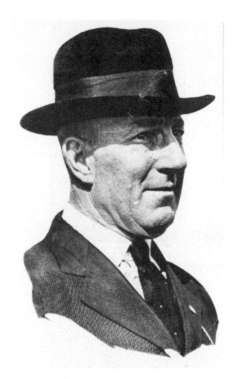

JACK DUNN AND THE ORIOLES RETURN, 1916.
The Federal League competition in 1914 nearly put Jack Dunn out of the baseball business, but he spent 1915 with his franchise in Richmond, Virginia, and survived. In 1916, with the Federal League and the Terrapins disbanded, he returned to Baltimore. He sold his Richmond Climbers and instead moved a Jersey City franchise to Baltimore, reclaiming the Oriole name. (The Babe Ruth Museum.)

THE ASSEMBLY YEARS, 1916–1918. From 1916 to 1918, the pieces that would eventually fit into seven consecutive pennant winners for Baltimore began coming together. In 1916, pitcher Jack Bentley was added; in 1917, pitcher Jack "Rube" Parnham; and in 1918, second baseman Max Bishop. In 1918, this telegram asking future Oriole great Merwin Jacobson to play for bottom dollar in Little Rock hastened his arrival in Baltimore in 1919. (The Babe Ruth Museum.)

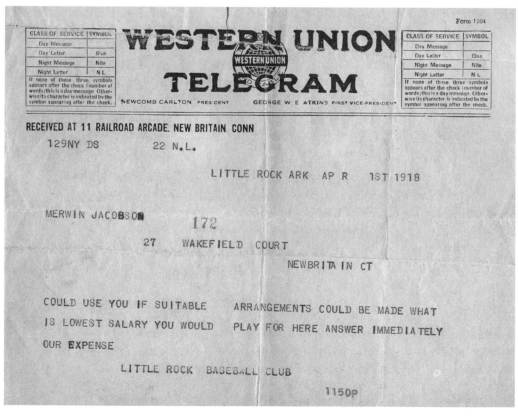

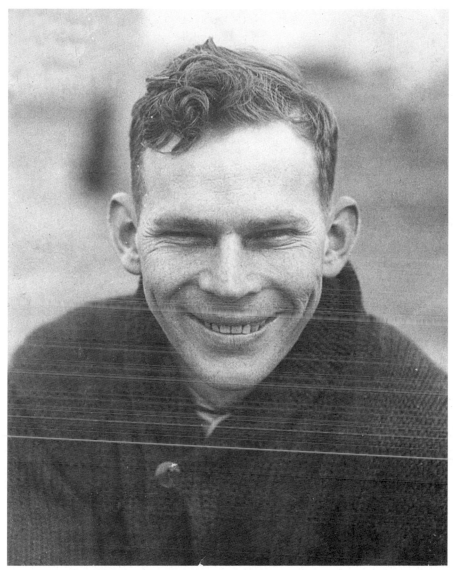

MERWIN "JAKE" JACOBSON, CENTER FIELDER, 1919–1924. "The Life of an International League Oriole" would be an apt title for the scrapbook that Merwin Jacobson's family bequeathed to the Babe Ruth Museum. Through its telegrams, newspaper clippings, and photographs, it sheds great insight into life for a top minor-leaguer on a top team. The highlights for Merwin included a .404 average in 1920 and ultimately induction into the International League Hall of Fame. The disappointments included swirling rumors about Jacobson heading to the majors, often to find that a major-league club's offer was insufficient for the savvy businessman Dunn. In baseball's pre-affiliated minor-league era, there was no promotion on demand by a major-league franchise from a minor-league affiliate. Fortunately for Baltimore, in Jake they had a player who never batted below .300 for six straight years. Fortunately for Jake, he enjoyed seven pennants, fan adoration, and time in the majors both before and after his time with the Orioles. (National Baseball Hall of Fame Library, Cooperstown, New York.)

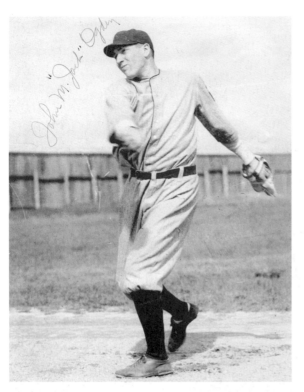

JOHN "JACK" OGDEN, PITCHER, 1920–1927. The arrival of Jacobson and the return of Fritz Maisel in 1919 helped lead the Orioles to their first pennant. Jack Ogden's arrival from Swarthmore College in 1920 went a long way in helping them to their second. His remarkable 27 wins in his first season led the league and accounted for one in every four Oriole victories that year. The next year, he won 31. (The Babe Ruth Museum.)

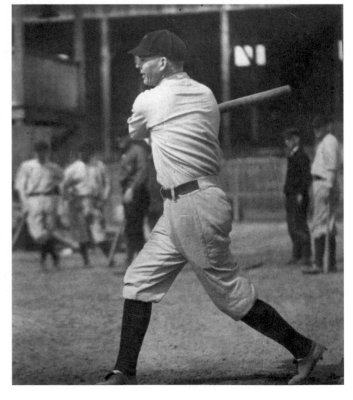

JAKE HITS .404 IN 1920. While Ogden took care of opposing hitters, Jacobson took care of opposing pitchers in 1920 by hitting .404. Recent statistical research revealed it may in fact have been the highest in the league's history at the time. (The Babe Ruth Museum.)

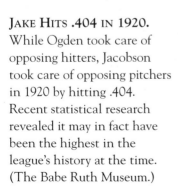

ROBERT MOSES "LEFTY" GROVE, PITCHER, 1920–1924. If the Orioles weren't set to dominate the next several years of International League play by the time of Lefty Grove's arrival in 1920, they certainly were afterward. Grove was overshadowed by righty Jack Ogden (27-9), lefty Jack Bentley (16-3), and Harry Frank (25-12) in 1920, despite an auspicious 12-2 start. (The Babe Ruth Museum.)

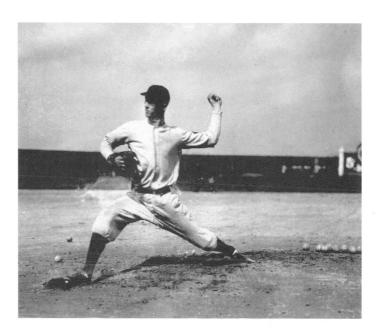

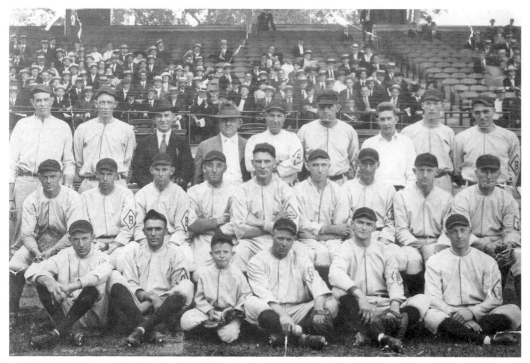

INTERNATIONAL LEAGUE CHAMPIONS, 1920. Pointing out the feats of the 1920 Orioles could in itself fill a volume. A shorter option is to point out a unique member: Jack Dunn Jr. In the third row, third from left, the younger Dunn served as a utility outfielder for the Orioles as late as 1918. By the time of this photograph, he was the team's capable business manager. Tragically he would die of pneumonia in 1923. (National Baseball Hall of Fame Library, Cooperstown, New York.)

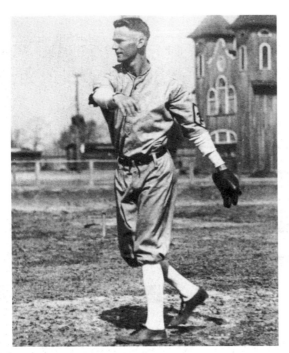

JOSEPH LEITER AITCHESON, 1921. Not all of the Orioles of the era were stars, and only two—shortstop Joe Boley and third baseman Fritz Maisel—were there for all seven pennants. Aitcheson was from Laurel, Maryland, and later had a son by the same name who would become a Hall of Fame steeplechase jockey. He was one of many local Marylanders who played briefly but contributed to the International League Orioles. (The Babe Ruth Museum.)

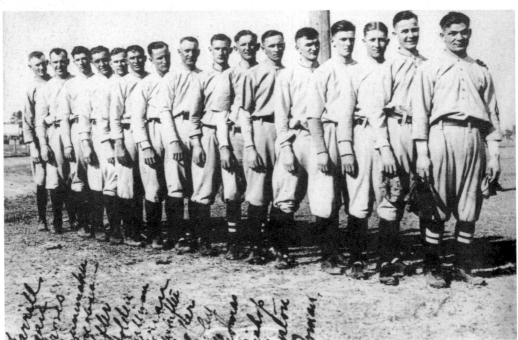

INTERNATIONAL LEAGUE CHAMPIONS, 1921. The 1921 team finished 119-47 and is ranked by Minor League Baseball's official web site as the second-best team in minor-league history. Included on the team, second from left, is Ben Egan, the same lanky catcher sold to the Red Sox in 1914 with the Babe and now returned to Baltimore. (National Baseball Hall of Fame Library, Cooperstown, New York.)

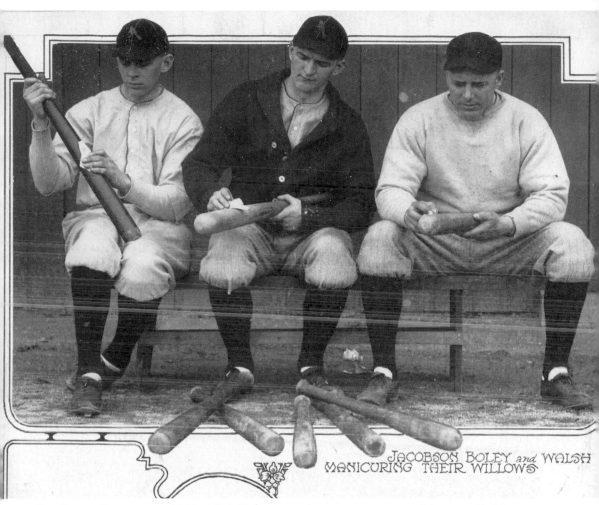

JACOBSON BOLEY and WALSH
MANICURING THEIR WILLOWS

JOE BOLEY, SHORTSTOP, 1919–1926. Boley (center) was a cornerstone of the great Oriole teams. He was an excellent fielder on teams that were best known for their overpowering pitching and hitting. He also pulled his weight at the plate, batting .343 for another pennant winner, the 1922 Orioles. Jack Dunn had a long-standing business relationship with Philadelphia's Connie Mack, and Boley was one of many Orioles to head to Mack's A's following his time in Baltimore. There he did what came naturally: win pennants. The A's took three straight from 1929 to 1931, besting the Ruth-Gehrig Yankees of the era. (Hearst Communications, Inc.)

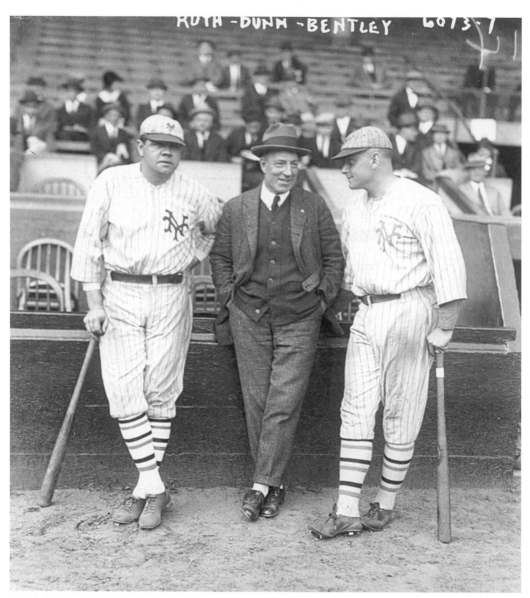

BABE RUTH, JACK DUNN, AND JACK BENTLEY, C. 1923. After winning their fourth straight pennant in 1922, Dunn parted with one of his earliest prizes of the post–Federal League era, Jack Bentley. Bentley joined the Orioles in 1916 and batted .378 from 1920 to 1922 (including a .412 average in 1921). He also hit 63 home runs and went 39-6 as a pitcher during the same period. Like Ruth, he was a lefty, could pitch, play the field, and hit. It earned him the nickname the "Minor League Babe Ruth." Here the real Ruth, Dunn, and Bentley enjoy a talk before an exhibition game in New York. The Babe has donned a Giants uniform for the shot, and Dunn has the look of complete contentment between two of his greatest former charges. Bentley batted .427 in 1923, failing to win the batting title due only to limited at-bats. He also went 13-8 on the mound. Back in Baltimore, the 1923 Orioles took their sixth straight pennant. (National Baseball Hall of Fame Library, Cooperstown, New York.)

JACOBSON AND THE O'S BY TKO, C. 1924. Although he didn't lead the league in batting in 1924, Jacobson once again batted over .300 and enjoyed life as the Orioles ran away with the pennant. The 1924 club is ranked fifth all-time on the greatest teams list compiled by Minor League Baseball. (The Babe Ruth Museum.)

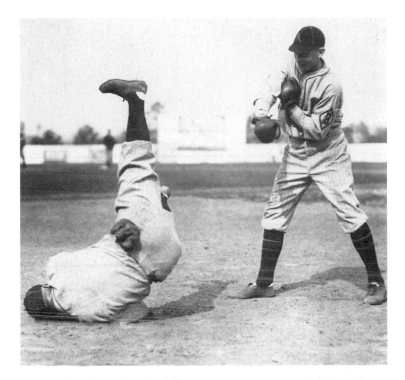

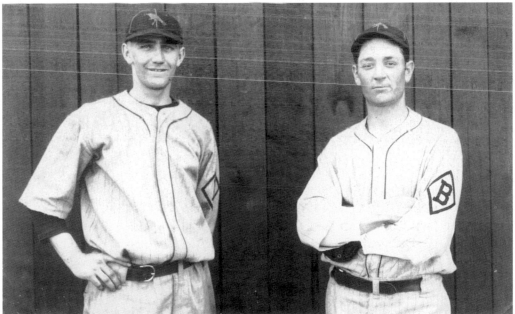

JOE BOLEY AND LARRY FISCHER, C. 1924. Another in the series of two-player promotional shots from 1924, this one features Joe Boley to the left. The player to the right, although unidentified on the picture, is likely outfielder Larry Fischer. Boley was on his sixth of seven pennant winners, while Fischer played in only 11 games but batted .355. He returned in 1925. (National Baseball Hall of Fame Library, Cooperstown, New York.)

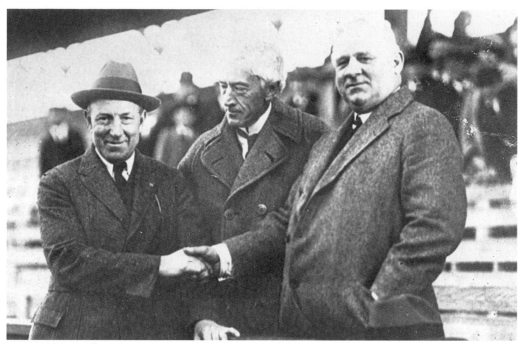

DUNN, LANDIS, AND MCGRAW AT ORIOLE PARK, C. 1924. Dunn and McGraw were old teammates, and in this 1924 shot, they shake hands for the camera as commissioner Kenesaw Mountain Landis looks on. Ever vigilant, he casts a wary eye at Dunn and wonders perhaps if these savvy baseball men have just cut a secret deal under the guise of a photo opportunity. (National Baseball Hall of Fame Library, Cooperstown, New York.)

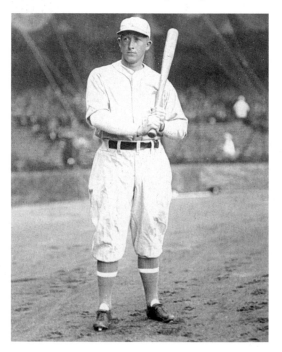

MAX BISHOP TO THE A'S IN 1924. In 1924, the longtime Oriole second baseman was sold to Connie Mack's Philadelphia A's. Bishop arrived in Baltimore in 1918 and departed after 1923 with five pennants to his credit. Like many Orioles, he returned for a stint with Baltimore in 1936 after a solid major-league career. (National Baseball Hall of Fame Library, Cooperstown, New York.)

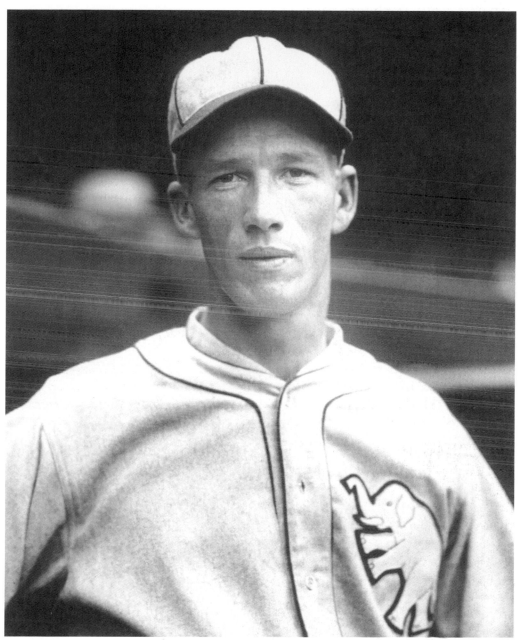

LEFTY GROVE TO THE A'S AND ORIOLES WIN THEIR SEVENTH, 1925. The slow exodus of top talent to the A's continued. Lefty's last year in Baltimore was a 26-6 season in 1924. At his market peak, he was dealt north to Philadelphia. In his first year with the A's, he led the AL in strikeouts and would do so for seven consecutive years. His career would extend for 17 years in the majors, and including his time with Baltimore, he would win well over 400 professional games en route to the Hall of Fame. In Baltimore in 1925, local product Alphonse "Tommy" Thomas amply picked up the slack by winning 32 games, and the Orioles won another pennant. (National Baseball Hall of Fame Library, Cooperstown, New York.)

AN ERA ENDING: 1926–1928.
Finally, in 1926, the pennant streak ended. That year Baltimore finished second, in 1927 fifth, and in 1928 fifth again. The passing of Jack Dunn late in 1928 marked the end of an era of success never to be matched. On the diamond, ace pitcher George Earnshaw (pictured here) departed for Philadelphia, and Fritz Maisel retired as an active player. (National Baseball Hall of Fame Library, Cooperstown, New York.)

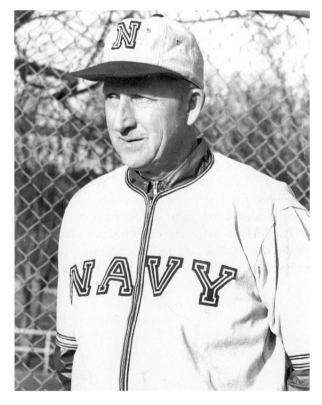

MAX BISHOP, NAVAL ACADEMY COACH, 1938–1961. Like the Old Orioles before them, many of the great International League Orioles went on to long coaching careers. Fritz Maisel and Tommy Thomas took the helm in Baltimore. Max Bishop headed up the Naval Academy's team and compiled a 306-143 lifetime record. Ben Egan and Jimmy Walsh also took high minor-league posts. (National Baseball Hall of Fame Library, Cooperstown, New York.)

THE INTERNATIONAL
LEAGUE O'S

1929–1953

After the boom 1920s, the Orioles settled into a long period of relative mediocrity. Off years were interrupted only by tremendous individual feats such as Joe Hauser's 63 home runs in 1930, Russ "Buzz" Arlett's 54 in 1932, and George Puccinelli's amazing triple-crown season of 1935.

The Orioles did not win a pennant again until 1944. In 1943, Jack Dunn III took control of the team after a series of leadership exchanges following his grandfather's death in 1928. As World War II raged overseas, a cobbling of youngsters and older veterans took the International League pennant for the first time since 1925. The Orioles then went on to best Louisville of the rival minor-league American Association to win the Junior World Series. In July, storied Oriole Park was lost to fire, and the Junior World Series was witnessed before record crowds at their cavernous new home, Baltimore's Municipal Stadium. These huge crowds raised the eyebrows of the majors, and Baltimore moved up the list of cities to receive a franchise.

The International League Orioles, along with the Negro Leagues' Baltimore Black Sox and Elite Giants, did more than merely bridge the wide gap between Baltimore's major-league entries. They took the city through the nation's hardest of economic times, the Great Depression, and also provided Baltimore with a diversion when it was most needed during World War II.

The fan base, in the absence of a steady winner, developed an appreciation for the developing player, the budding star, and an enduring loyalty to the many veterans who returned "home" to Baltimore as their careers waned. These qualities distinguish the city's baseball fan base to this day.

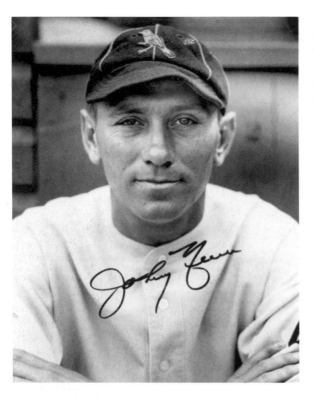

JOHNNY NEUN, 1929. After an off year with Detroit in 1928, Baltimore native Johnny Neun came to the Orioles in 1929 and quickly righted course. By 1930, he was back in the majors with the Boston Braves and batted .325. (The Babe Ruth Museum.)

JOE HAUSER HITS 63 HOME RUNS, WATERS HOUSE PLANT, C. 1930. Joe Hauser dropped down to the minors in 1930 and quickly made his presence felt. He belted 63 home runs for the Orioles, the highest professional tally in a single season at the time. Another Hauser all-time first may be this picture of a home run slugger watering a house plant. (National Baseball Hall of Fame Library, Cooperstown, New York.)

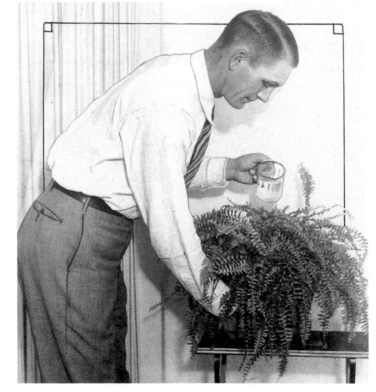

JIMMIE FOXX IN AN O'S UNIFORM, C. 1931. The Philadelphia A's successfully kept the powerful Yankees at bay from 1929 to 1931 with help from Jimmie Foxx and a handful of ex-Orioles, including Boley, Bishop, Grove, and Earnshaw. Here Foxx dons the uniform of the Orioles and takes batting practice at Oriole Park. The occasion was probably an exhibition game between Philadelphia and Baltimore. The Orioles can't be blamed for missing the Marylander who would slug 538 career homers, including 58 in 1932, as he signed on with the A's in 1925 at age 17 and stayed in the majors for 20 seasons. (Blair Jett.)

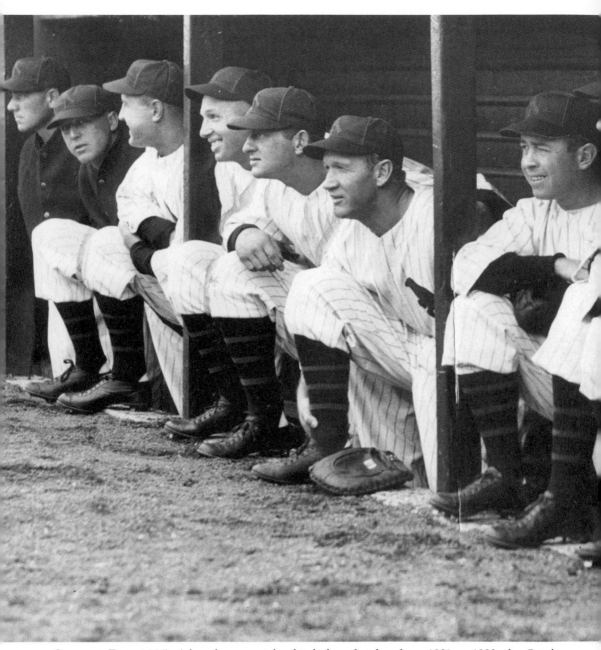

OPENING DAY, 1935. After three straight third-place finishes from 1931 to 1933, the Orioles fell to last place in 1934. By Opening Day in 1935, they were eager to return to the league's first division. They would improve from 1934 to an above-.500 finish at 78-74. The true highlight of the season would be the performance of George Puccinelli. Fifth from the left, "Pooch" is on the

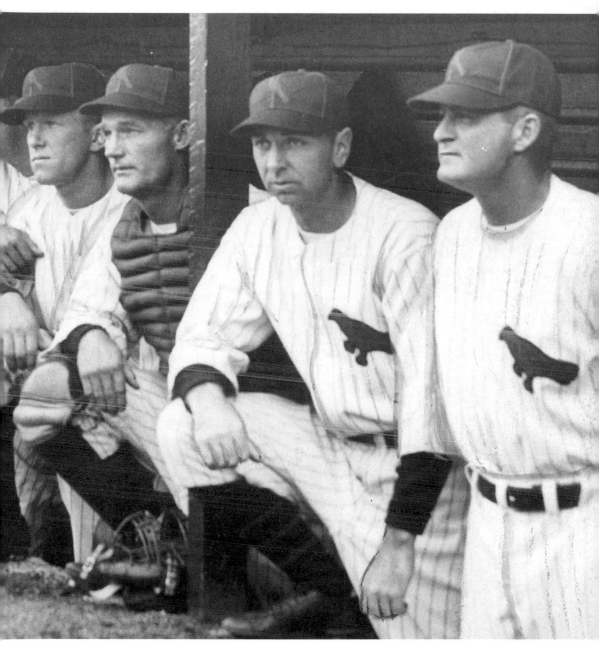

threshold of a triple-crown season, surely one of the best in the history of any league. He hit 53 home runs, batted in 172 runs, and hit for a .359 average. The next season, he was back in the majors with Philadelphia. (Hearst Communications, Inc.)

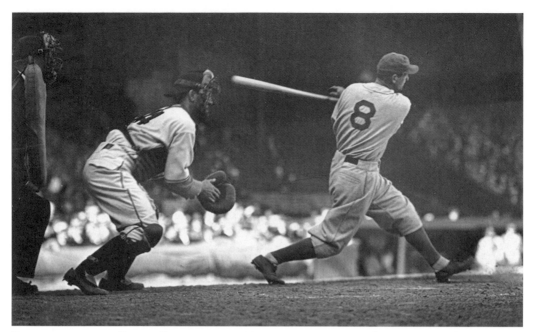

PUCCINELLI AT THE PLATE, PHILADELPHIA A'S, 1936. Not surprisingly, in 1936, Pooch was back in the majors, this time with the Philadelphia A's. He had a solid year, driving in 78 runs and batting .278 in 135 games. Inexplicably he was back down to Baltimore in 1937 and resumed driving in runs and hitting for average. (National Baseball Hall of Fame Library, Cooperstown, New York.)

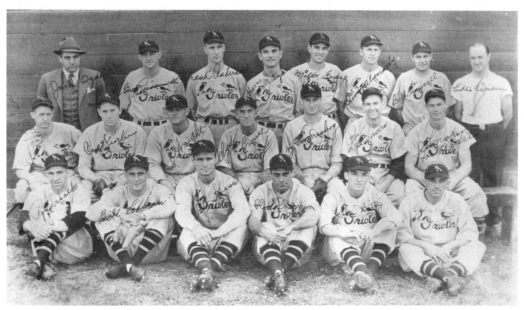

BALTIMORE ORIOLES, 1937. In 1937, Clyde "Bucky" Crouse (center) took the helm of the Orioles after arriving from the Buffalo Bisons. At age 40, he still got behind the plate for 101 games. In the third row to the far left is legendary Oriole pitcher Jack Ogden, now a scout, and to the right is the returned Puccinelli. (The Babe Ruth Museum.)

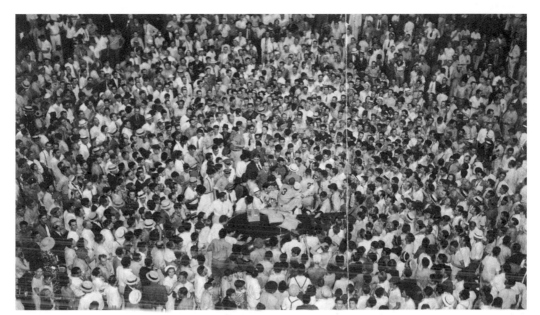

BUCKY CROUSE APPRECIATION DAY, SEPTEMBER 1937. Centered in the crowd, atop a car he's just been presented, is the well-appreciated Bucky Crouse. That year's club finished fourth, 32½ games behind the powerful Newark Bears, but Crouse captured the International League's MVP award. (Hearst Communications, Inc.)

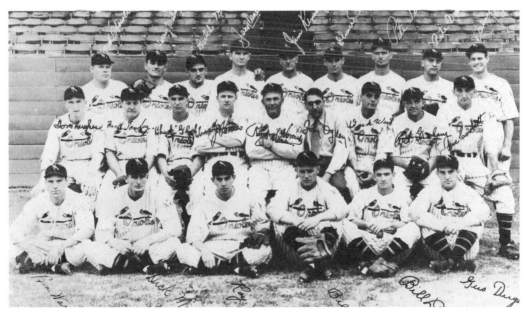

BALTIMORE ORIOLES, 1939. The biggest name in this photograph is in its center, manager Rogers Hornsby. Hornsby was one of the greatest right-handed hitters in baseball and would be in the Hall of Fame by 1942. Arriving in Baltimore in 1938 as a player at the tail end of his career, he would enjoy only one year as the Orioles' manager. Seated to the left of Hornsby is his 1940 replacement, Tommy Thomas. (Blair Jett.)

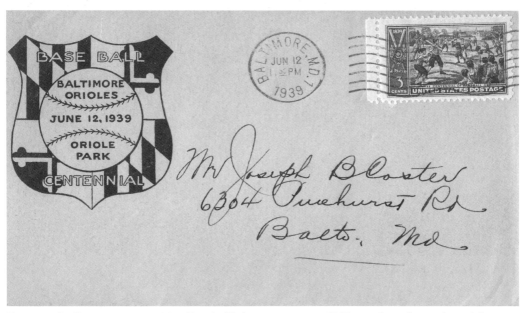

ODD FELLOWS NIGHT TICKET, 1939. Baseball tickets are the perfect souvenir. Sixty-eight years later, this ticket gives the price, the time, the place, the opponent, the sponsor, and the seating area for a single game on a July night. This ticket even tells the weather: rain. With the stub intact and stamped, "Ticket Good Any Game," the bearer probably never made it through the turnstiles.

BASEBALL'S CENTENNIAL, 1939. Baseball's biggest story in 1939 may have been the celebration of its centennial. Based on the largely debunked notion that Abner Doubleday invented the game in the summer of 1839, the majors and minors commemorated the event in a wide variety of ways. The Orioles did their share on their envelopes, and the U.S. Post Office did theirs with their stamps. (Blair Jett.)

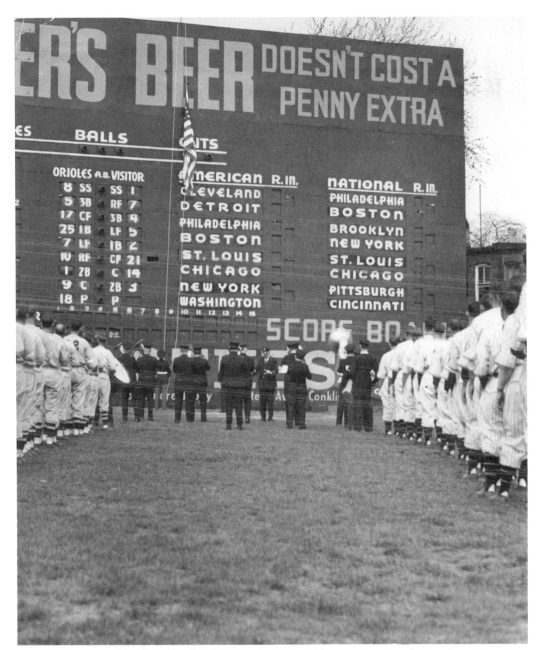

ORIOLE PARK, OPENING DAY, APRIL 16, 1942. With the attack on Pearl Harbor in December 1941, Opening Day in 1942 arrived with America just several months into a new war. The Orioles lined up for their opener against the Rochester Red Wings as the band played and the flag was patriotically raised. Although the Orioles pulled off a triple play that afternoon before 7,000 fans, it was still not enough, as the Red Wings prevailed 12-6. The Orioles finished the 1942 campaign at 75-77. (Hearst Communications, Inc.)

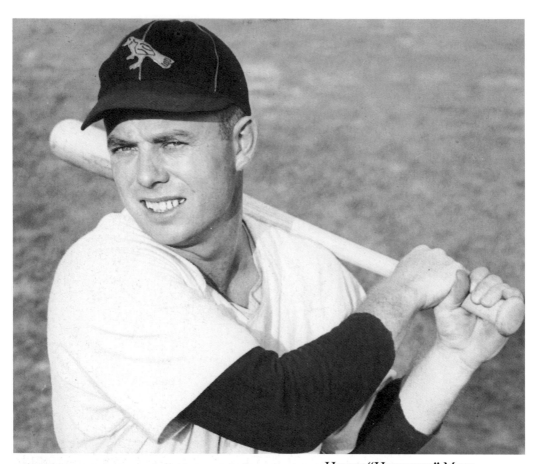

**HOWIE "HOWITZER" MOSS
ACQUIRED AFTER 1943 CAMPAIGN.**
In 1943, 25-year-old Howie Moss was playing outfield for the eighth-place Jersey City Giants and batting .233. Acquired by the Orioles for the 1944 season, Moss responded to the change of scenery. He belted 27 home runs, drove in 141 runs, and batted .306 to win the International League's MVP. In 1946, he hit 38 home runs and, in 1947, 53 homers. During his six-season International League career, Howitzer sent 172 homers into the seats and drove in 579 runs. (Blair Jett.)

JOHN SHERMAN "SHERM" LOLLAR, C. 1944. In 1943, a teenaged Sherm Lollar quietly joined the Orioles. He played in only 12 games and batted lightly. The next year, still only 19 on Opening Day, he blossomed. An excellent fielding catcher, he stepped in for the Orioles and solidified the spot with 116 games behind the plate. His next season, 1945, would be an offensive bonanza, as he won the league batting title and MVP awards. Once in the big leagues, he won the original Gold Glove Award, given out to the best fielding player at each position. (Blair Jett.)

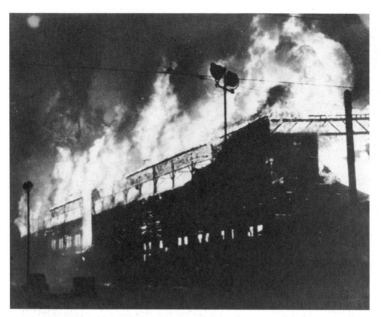

ORIOLE PARK LOST TO FIRE, JULY 3–4, 1944. On July 3, 1944, the Orioles lost a 10-inning contest to the Syracuse Chiefs. After the game, the wooden bleachers that had hosted millions of fans since 1914 were hosed down as usual, but a smoldering ember escaped the dousing. The park went up like straw, and the team lost everything it owned, from baseballs to the park itself. (Blair Jett.)

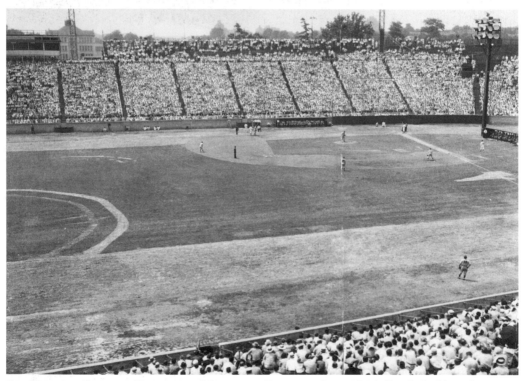

PRESSED INTO SERVICE: BALTIMORE MUNICIPAL STADIUM, JULY 1944. Oriole Park's replacement was the cavernous Baltimore Municipal Stadium, originally named Venable Stadium and completed in 1922. Municipal was a bowl-shaped football stadium encircled by a track, and this photograph just two weeks after the Oriole Park fire reveals a structure hastily refitted for baseball. It also reveals a packed house. (Hearst Communications, Inc.)

JUNIOR WORLD SERIES, MUNICIPAL STADIUM, OCTOBER 1944. The Orioles won the International League pennant and then went on to face the Louisville Colonels in the Junior World Series. The series dated back to 1905 and pitted the International League champion against the rival American Association. Baltimore won four games to two, and the series outdrew the Browns-Cardinals World Series of the same year. (The Babe Ruth Museum.)

ORIOLES PROGRAM, 1945. The color original of this 1945 program blazes in red, white, and blue, and the Orioles longtime skipper and former pitcher Tommy Thomas is the center of the patriotic ensemble. By VE Day in May, the Orioles were still in the thick of things; by VJ Day, it was apparent that Orioles would not be repeat champions. (Blair Jett.)

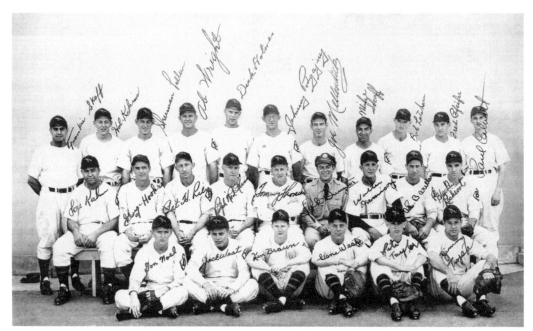

BALTIMORE ORIOLES, 1945. Although not pennant winners, the 1945 Orioles finished 80-73 and were the last of the wartime Orioles. MVP Sherm Lollar (third row, third from the left) has reason to smile, as does uniformed team president Jack Dunn III. (Enoch Pratt Free Library.)

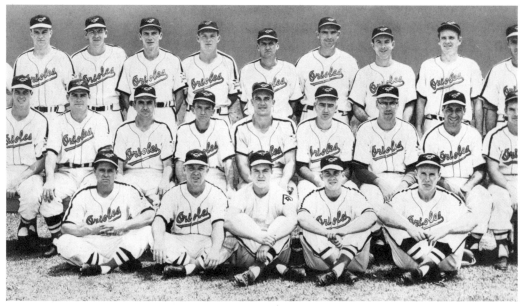

BALTIMORE ORIOLES, 1953. The years between 1944 and 1953 were not without their highlights, including the all-time International League Orioles attendance mark of 607,352 fans in 1946 and Moss's 53 home runs in 1947. There would be no repeat pennant, but this 1953 team would end the International League Orioles' legacy as winners, going 82-72 and closing out the franchise's long history in fitting fashion. (Enoch Pratt Free Library.)

6

BLACK SOX AND ELITES

NEGRO LEAGUE BASEBALL

The Negro League era generally dates back to the establishment of the Negro National League, or NNL, by Texas-born pitcher Rube Foster in 1920. For nearly 20 years prior, Foster led successful independent touring teams, but he realized that in order to prosper and gain stability, both his team and his opponents needed to band together in a league.

The owners of Baltimore's Black Sox followed suit several years later, helping to found the Eastern Colored League, or ECL, in 1923. Like Foster's teams, the Black Sox were successful as an independent team, but they had a difficult time filling seats against uneven competition. League play was needed.

After going 49-12 in 1922, the Sox, facing stiffer competition, slumped to 19-30 in 1923. It wasn't until 1929 that they had a pennant of their own, this time in the ECL's successor, the American Negro League.

From 1930 to 1934 the Sox alternated between league and independent play before folding in the depths of the Depression at the end of 1934.

In 1938, baseball returned with the Baltimore Elite Giants, or "Elites," from Nashville. They finished only 12-14 in a shortened season but showed promise. Pitcher Bill Byrd and Biz Mackey were bona fide Negro League stars, as was 17-year-old rookie catcher Roy Campanella. In 1939, Baltimore took advantage of its veteran and developing talent. In the second half of the split-season year, the Elites finished third but made it through the two rounds of playoffs. First they beat the perennially strong Newark Eagles, and then they ousted their annual tormentors, the Homestead Grays, before 15,000 at Yankee Stadium to take the pennant.

The Elites took another split-season first-place finish in 1942 but fell in the playoffs to the Grays.

In 1947, Brooklyn's Jackie Robinson broke the color barrier, and the migration of top Negro League talent into the majors began. It was a trickle at first but built into a stream as stars such as Larry Doby, Campanella, and Monte Irvin quickly proved their stuff. The Elites, now in a reconfigured Negro American League, took the city's final Negro League pennant in 1949 as they beat Chicago's American Giants.

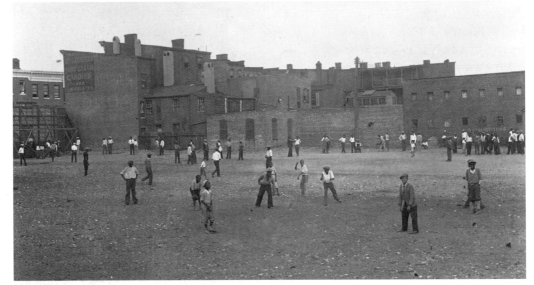

CHILDREN PLAYING BASEBALL, C. 1900. Prior to the Rube Foster–era Negro Leagues, Baltimore hosted a number of African American teams. Two Baltimore teams, the Lord Hannibals and Orientals, played at Newington Park as early as 1874. In 1887, a short-lived Colored League included New York, Philadelphia, Boston, and Baltimore entries. There was also the ever-present popularity of the sport in the community, as seen in this *c.* 1900 sandlot shot. (The Maryland Historical Society.)

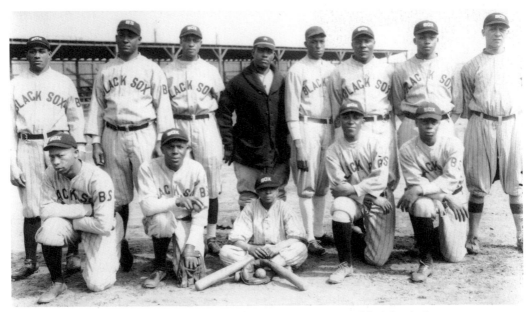

BALTIMORE BLACK SOX, 1924. The Black Sox were a successful independent team prior to becoming a founding member of the ECL. There the completion stiffened, and after an off year in 1923, they retooled for 1924 and finished 30-19. Included here of note are slugger John Beckwith (first row, second from the right), Jud Wilson (second row, third from the right), and outfielder Crush Holloway (second row, third from the left). (Transcendental Graphics.)

ERNEST JUSTIN "JUD" WILSON.
Hall of Famer Jud Wilson's career
began with the 1922 Black Sox and
extended through the 1945 season.
He was pursued by and played for
virtually every prominent eastern
Negro League team, including
the Homestead Grays. His career
average is estimated at .345. Intense
on the field, he hated sitting on the
bench as much as he hated umpires
and rarely came out when injured.
(National Baseball Hall of Fame
Library, Cooperstown, New York.)

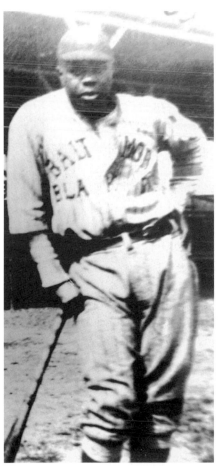

JOHN BECKWITH, C. 1930. Like Wilson, Beckwith
played for nearly every major eastern Negro League
team. A power hitter and versatile fielder, he could
hit for average and won the 1925 ECL batting title
with a .404 mark. He had two stints with the Black
Sox, spaced four seasons apart, as well as two stays
with Rube Foster's Chicago clubs. (National Baseball
Hall of Fame Library, Cooperstown, New York.)

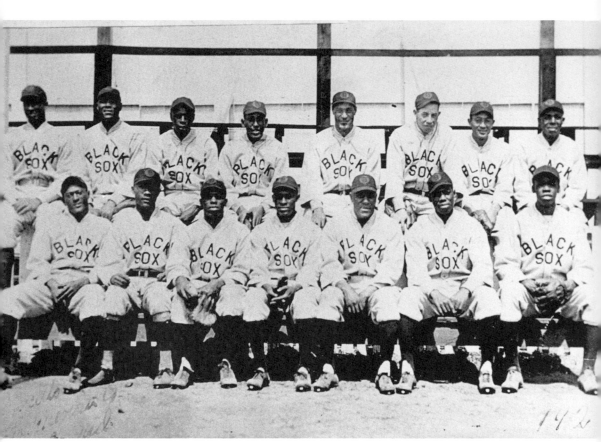

AMERICAN NEGRO LEAGUE CHAMPIONS, 1929. Far fewer photographs exist of the Black Sox than their successors, the Elite Giants, but fortunately this 1929 shot is still preserved. The 1929 American Negro League included a handful of familiar foes from the old ECL, including the Grays. New arrivals second baseman Frank Warfield, shortstop Dick Lundy, and third baseman Oliver Marcelle joined Jud Wilson to form the Negro Leagues' "Million Dollar Infield." Warfield, Wilson, and Lundy are in the first row, fourth, fifth, and sixth from the left, and Ollie Marcelle is fourth from the right in the second row. The Sox won both halves of a split season behind the arm of Laymon Yokeley. Yokeley, to the far right in the first row, won 17 games. There was no Negro League World Series with the rival Negro National League and its Kansas City Monarchs, so the Black Sox contented themselves with a 6-2 postseason record against barnstorming major-league all-stars. The pinnacle of the Sox league years was 1929, although their 1930 independent team was strong, and they were in first when their league folded in 1932. (The Babe Ruth Museum.)

LEROY "SATCHEL" PAIGE, C. 1950. Photographs of Satchel with the Black Sox may not exist, but he was with the non-league independent Sox in 1930 and went 9-4 before departing mid-season. Just 23 when he joined, the young Paige reportedly was ribbed as a bumpkin or "Rube" (early baseball's one-size-fits-all nickname) by some of his veteran teammates and departed hastily, en route ultimately to Cooperstown. (National Baseball Hall of Fame Library, Cooperstown, New York.)

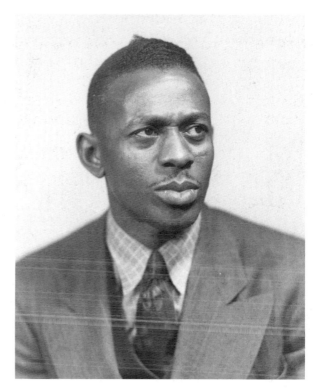

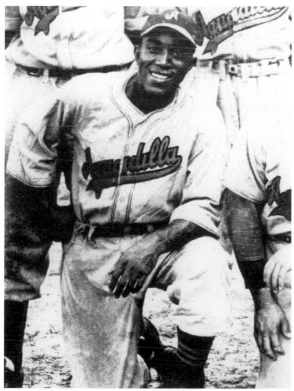

LEON DAY, C. 1936. In their final year of existence in 1934, the Black Sox played in Chester, Pennsylvania. There they were joined by another promising young pitcher, Leon Day. Shown here with Puerto Rico's Aguadilla team, Day pitched virtually year-round. Day fortunately returned to the city in the last years of his career to boost the Elite Giants. (National Baseball Hall of Fame Library, Cooperstown, New York.)

BASEBALL IN BALTIMORE

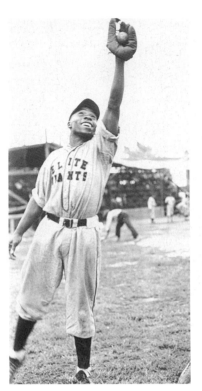

HENRY KIMBRO, BALTIMORE ELITE GIANTS, CENTER FIELD. Henry Kimbro arrived with the Elites in Baltimore in 1938. He would spend 13 years of his 16-year career with the club and appeared in six all-star games. Fast with a good arm, he often batted in the mid-.300s. Judging in terms of longevity with the team and overall ability, Henry was probably the greatest of the Elites. (National Baseball Hall of Fame, Cooperstown, New York.)

ROY CAMPANELLA AND SAMMY HUGHES. Sammy Hughes and catcher Roy Campanella were also with the Elites in 1938, when they began play in Baltimore. Campanella's travels are well known; he would go on to stardom with the Brooklyn Dodgers and is one of the greatest catchers in history. Less known are the talents of Hughes. At 6 feet, 3 inches—a towering second baseman—he made five Negro League all-star appearances and was a longtime, stellar Elite. (Getty Images.)

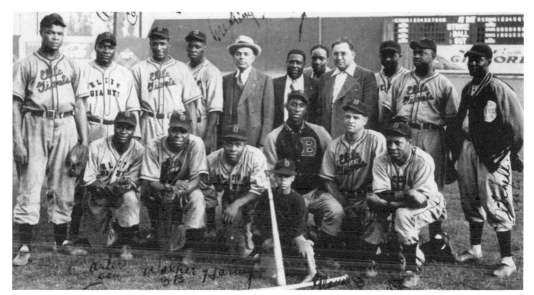

ELITE GIANTS, CALIFORNIA WINTER LEAGUE, 1939. The eastern version of the Baltimore Elite Giants won the team's first pennant, besting perennial foils the Newark Eagles and Homestead Grays in the process. This unique photograph of an Elites club (dubbed either Baltimore or Nashville) is a western version, playing in the professional, integrated California Winter League from early October through February each year.

BILL BYRD AND FELLOW ELITES, C. 1942. Although unlabeled, this shot was likely taken in 1942 and features, from left to right, Granville Lyons, Thomas "Pee Wee" Butts, Bill Hoskins, Bill Byrd, Charles Carter, and Sammie Hughes. Byrd was an all-star pitcher and solid hitter. He often dueled Leon Day until Day finally joined him with the 1949 Elites. His lifetime record in the Negro Leagues is 114-72. (The Babe Ruth Museum.)

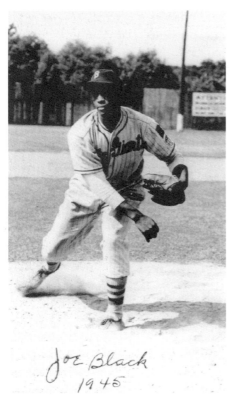

Joe Black
1945

JOE BLACK, C. 1945. Just as Dunn often did in seeking out his Orioles, the Elites looked locally to find Joe Black on the campus of Morgan State College (now university). Black joined the Elites in 1943 but shortly thereafter was drafted into the military and missed the better part of two seasons. Joe rejoined in late 1945 and in 1946 was rusty, finishing 4-9 on the year. He then developed sharply over the next three seasons and helped the team to their next pennant in 1949. After time in the minors and winter league from 1951 to 1952, Joe debuted with the Brooklyn Dodgers in the spring of 1952 and went 15-4 to earn Rookie of the Year honors. He pieced together six seasons in the majors, finishing 30-12 lifetime, and later returned to his home state of New Jersey for postgraduate studies at Seton Hall and Rutgers. From there he served as a senior executive with Greyhound Corporation, a fitting accomplishment for a player who spent so much time in his ball-playing days on the road. (at left, the Babe Ruth Museum; below, © Bettmann/Corbis.)

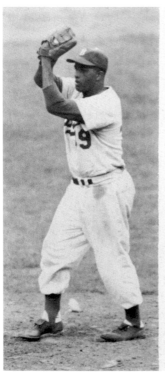

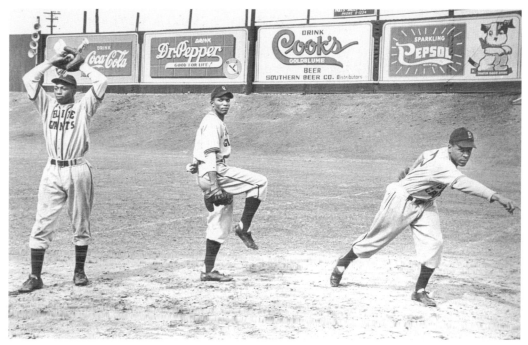

ED BURKE, BOB ROMBY, AND GEN JACKSON, 1947. From left to right, Burke, Romby, and Jackson were solid contributors and kept the Elites thriving. This shot was likely snapped at Nashville's Sulphur Dell. Although relocated to Baltimore, the team kept ties with Nashville, and this may be a spring training photograph. Sulphur Dell's right field was baseball's oddest, and right fielders were called "mountain goats" due to the skills required to man the position. (The Babe Ruth Museum.)

KIMBRO, DAVIS, LOCKETT, AND PEARSON AT BUGLE FIELD, 1949. This picture of the Elites is either of their four featured outfielders or four best hitters in 1949. From left to right, Kimbro batted .352; outfielder Butch Davis batted .371; outfielder/infielder Lester Lockett was a 1948 all-star slugger and long-ball threat; and Lennie Pearson, the player-manager, hit .332 in 1949. (The Maryland Historical Society.)

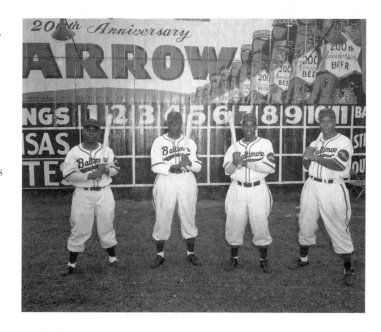

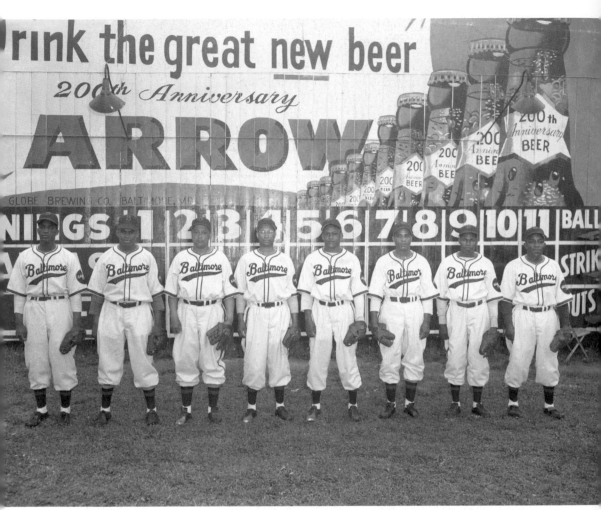

BALTIMORE ELITES PITCHING STAFF, BUGLE FIELD, 1949. Given the prominence and sheen of the newly painted sign behind them, Arrow Beer marketers probably chose the location of this great shot (and the previous photograph) of the 1949 Elites pitching staff. From left to right are Joe Black, Leroy Ferrell, Bill Byrd, Charles "Specs" Davidson, Al Wilmore, Bob Romby, Sylvester Rodgers, and the returned twilighter Leon Day. With major-league baseball now integrated, many Negro League teams saw a runoff of talent. This Elites team may very well have been the last great team in Negro League history. The team also included second baseman Jimmy "Junior" Gilliam. Upon his debut in the majors with the Dodgers in 1953, Gilliam followed Joe Black as the circuit's rookie of the year. Along with six-time all-star shortstop Thomas "Pee Wee" Butts, the Elites were rock solid up the middle. The 1949 team ousted the Chicago American Giants in four straight games to take the Negro American League pennant. By 1950, the Elites time as a franchise began to wind down. (The Maryland Historical Society.)

LEON DAY. By the time the majors integrated, Leon Day's arm was too wearied from non-stop usage for him to be considered a prospect. He played summers in Newark and Baltimore and winters in Venezuela, Mexico, and Puerto Rico. He even put extensive mileage on his arm in World War II, pitching in a number of contests in 1945 (his 1944 service included participation in the Normandy invasion). In 1950, he departed Baltimore's Elites and finished out his career playing in Canada without being approached by the majors. Around the time of this photograph in 1995, his lifetime of accomplishments was belatedly recognized, and he was inducted into the Hall of Fame. Sadly he died less than a week after his notification of induction in March 1995 at age 78. (National Baseball Hall of Fame Library, Cooperstown, New York.)

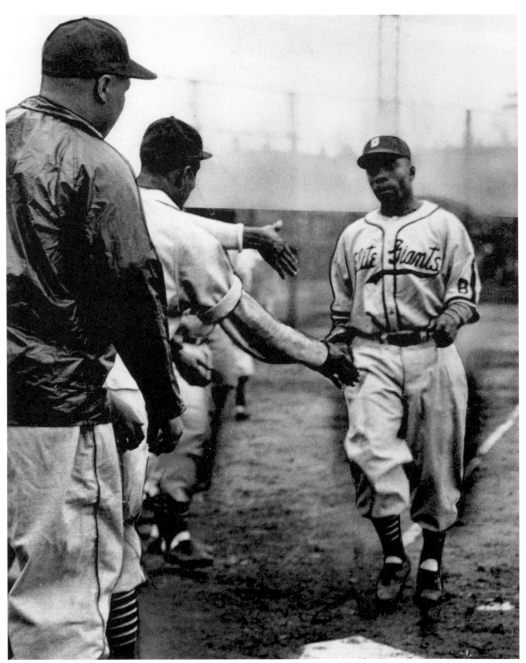

HENRY KIMBRO TO BIRMINGHAM, 1951. Kimbro stayed on with the Elites until 1951, their last year as a Baltimore team. Most of that season was spent on the road, and by 1952, the Elites returned to Nashville for a final barnstorming season before disbanding. Henry moved after 1951 to the Birmingham Black Barons and finished his career with them in 1953. A constant base-stealing threat, Kimbro led the league in steals in 1944. That year he also batted .329 and finished just one home run behind Josh Gibson and Buck Leonard for the league lead. (The Babe Ruth Museum.)

BLACK SOX AND ELITES: NEGRO LEAGUE BASEBALL

BACK IN THE MAJORS

1954–PRESENT

In 1954, the majors finally returned. The hapless St. Louis Browns, finishing 46½ games out of first place in 1953, moved to Baltimore. It was a steep climb up from 1953, as the Browns were far closer to an expansion team than a transplanted one in quality. By the late 1950s, head coach and general manager Paul Richards had sown the seeds of what would ultimately produce a dynasty.

Richards is generally credited with developing "The Oriole Way," a consistent method of instruction that emphasized pitching, defense, and the subtle details of fundamentally sound baseball. It was drilled into all players in the Oriole system, from the lowest level minor-leaguer up to the major-league O's.

The minor-league system began to provide a steady pipeline of talent by the early 1960s, and by 1964, the Orioles finished just two games away from an American League pennant under new manager Hank Bauer. By 1966, the pennant, and a convincing World Series title, would belong to Baltimore. Frank Robinson, in his first season with the Orioles after being acquired via trade from the Reds, would win the Triple Crown with 49 home runs, 122 runs batted in, and a .316 average.

From 1966 to 1971, the Orioles took the pennant four times and the World Series twice in establishing themselves as the American League's premier team of that era. In 1979 and 1983, the Orioles ascended to series heights again, winning it all in 1983.

The 1980s saw both great achievements and great depths for the young Orioles. Five years after the 1983 crown, the Orioles lost their first 21 games. In 1989, they bounced back and narrowly missed claiming first place in the American League East. The 1997 Orioles went "wire-to-wire" by spending every day of the season in first place and represented the best O's team of the decade.

As the new century began, the Orioles could look to a wide variety of teams, from Dunn's Orioles to the Elites to manager Earl Weaver's powerhouses, for drive to return to Baltimore's championship heights.

GUNTHER'S BEER RADIO ADVERTISEMENT WITH CHUCK THOMPSON, 1952. Before major-league Orioles even arrived in town, announcer Chuck Thompson was already the play-by-play man for Gunther's broadcasts of International League Oriole games. Chuck announced for the Orioles intermittently for over 40 years and won the Ford C. Frick award in 1993 for his stellar broadcasting career. Chuck's signature "Ain't the beer cold?" is synonymous with the Orioles radio broadcasts. (Blair Jett.)

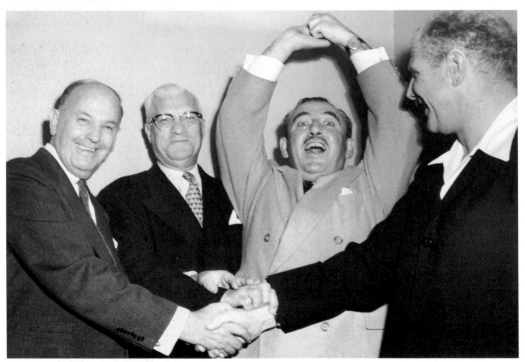

BALTIMORE MAYOR APPROVES OF ORIOLES MOVE. Mayor Thomas D'Alessandro is clearly elated over the agreement of St. Louis Browns' owner Bill Veeck (far right) to sell his team to Baltimore owners. Veeck had notions of moving the Browns to Milwaukee or Los Angeles, but his fellow American League owners essentially forced his hand, fortunately in Baltimore's direction. (Blair Jett.)

BACK IN THE MAJORS: 1954–PRESENT

"BULLET" BOB TURLEY AND EDDIE
WAITKUS, MAY 1954. Bullet Bob (left)
was the first Orioles star, leading the league
in strikeouts in the team's initial season of
1954 with 185. That winter, he was dealt
to New York as part of a 17-player trade,
the largest in baseball history. Waitkus
was at the end of a solid but star-crossed
career; in 1949, he was shot by a crazed fan
and provided some inspiration for Bernard
Malamud's *The Natural*. (Getty Images.)

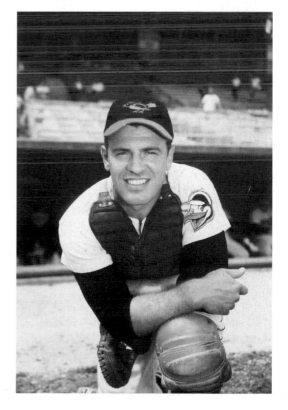

GUS TRIANDOS, CATCHER. The offseason
trade that sent Turley to New York
essentially rid the Orioles of former Browns
players and brought in younger prospects.
Amongst them was Gus Triandos,
previously stuck in New York behind Yogi
Berra. Triandos responded to the change
of environment and was an AL all-star
from 1957 to 1959. (© Bettmann/Corbis.)

F. J. SHAUGHNESSY, PRESIDENT-TREAS.
JACK KENT COOKE, VICE-PRESIDENT
HARRY SIMMONS, SECRETARY

INTERNATIONAL LEAGUE
OF
PROFESSIONAL BASEBALL CLUBS

1121 ST. CATHERINE ST. WEST
MONTREAL 2, QUE.

VICTOR 9-6123

CLUB MEMBERS

BUFFALO, N.Y.
COLUMBUS, O.
HAVANA, CUBA
MIAMI, FLA.
MONTREAL, QUE.
RICHMOND, VA.
ROCHESTER, N.Y
TORONTO, ONT.

9th December, 1957.

Mr. Merwin Jacobson,
431 Rosebank Ave.,
Baltimore 12, Md.

Dear Merwin:

I regret the long delay in sending you the enclosed International League Lifetime Pass and a photo of the League's Hall of Fame plaque which hangs in our office.

We have been trying to get these things together since before the season's start, but first one thing and then another, proved unsatisfactory or was held up unreasonably. But at long last, it is done.

Please permit me on the part of the League and its members, and on behalf of the League's Baseball Writers' Association, which had the honour of electing you to the Hall of Fame, to wish you our congratulations and hearty good wishes.

Cordially yours,

Harry Simmons,
Secretary

JAKE MAKES THE INTERNATIONAL LEAGUE HALL, 1957. Like Leon Day, Merwin Jacobson had a long wait for recognition of his outstanding career. In 1957, it finally came, and Jake was inducted into the International League Hall of Fame. Note the mention in the upper right of the induction letter of a Havana, Cuba, entry. This was the new home of the IL Orioles when they sold the rights to the Oriole name and left the city upon the majors' arrival. In the shot below, taken several years later, Jake enjoys life after baseball and takes a pointer from Stan Musial as longtime Baltimore sportswriter John Steadman looks on. (The Babe Ruth Museum.)

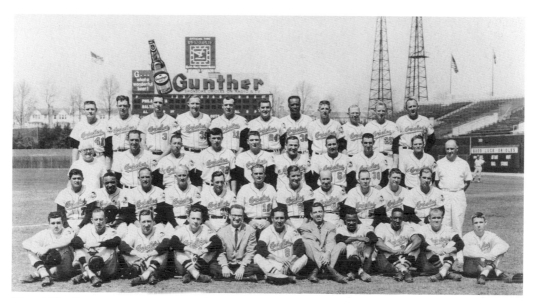

THE 1959 BALTIMORE ORIOLES. The 1959 Orioles were under the direction of Paul Richards (sixth from the left, second row.) Richards took charge in 1955 after managing into 1954 with the White Sox. He was hired as both the manager and general manager. The 1959 Orioles finished sixth but then rallied to second behind the Yankees in 1960. Most of the names on this roster didn't figure heavily into the successful Oriole teams of years to come, with a notable exception. Three players to the right of Richards is 22-year-old Brooks Robinson, who would sit for every Orioles team picture through 1977. (The Enoch Pratt Free Library, gift of Gunther Brewing.)

BROOKS "BROOKSY" ROBINSON, 1960. The accolades garnered by Robinson and the glove work he shows here are too lengthy to list. Simply put, he was the greatest fielding third baseman in history. A few assertions validating that notion include 16 Golden Gloves, 15 straight All-Star selections, and virtually every third baseman career record including most games, best fielding percentage, most putouts, most assists, and most chances. (National Baseball Hall of Fame Library, Cooperstown, New York.)

BASEBALL IN BALTIMORE

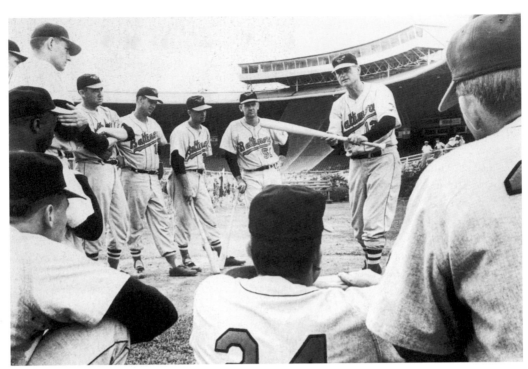

"THE ORIOLE WAY," 1960. Richards teaches bunting here in the same way that it was taught throughout the organization at the time. This core method of teaching became "The Oriole Way." A top student and then teacher of the Oriole Way was minor-leaguer Cal Ripken. He would later coach and pass on its legacy to thousands of young players as well as his sons, Billy and Cal. (National Baseball Hall of Fame Library, Cooperstown, New York.)

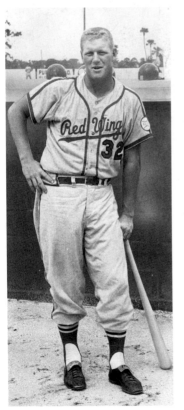

JOHN WESLEY "BOOG" POWELL, ROCHESTER RED WINGS, C. 1961. Boog Powell made a brief appearance with the Orioles in 1961, but the majority of his time that year was in the minors. In 1962, he stepped in and played 124 games, mostly in the outfield. He would continue to develop and become one of the decade's best power-hitting first basemen. (National Baseball Hall of Fame Library, Cooperstown, New York.)

"DIAMOND" JIM GENTILE, 1960–1963. One reason that Boog Powell found himself in the outfield during his early years was because of the presence of Diamond Jim Gentile at first base. In those pre-designated-hitter days in the AL, there was no extra slot for a big heavy hitter in the batting order. Offensively, Gentile's 1961 season at first base still ranks as one of the best in team history. As Powell developed with the glove, he eventually replaced Gentile, and by 1964, Jim was with the Kansas City A's. (Both the National Baseball Hall of Fame Library, Cooperstown, New York.)

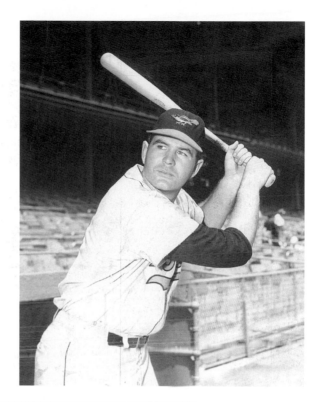

ABETTING THE (FUTURE) ENEMY, 1961. Instructing a high school all-star team sponsored by Hearst's *Baltimore News-Post*, Oriole coach Billy Hunter unknowingly is teaching an apt pupil who will come back and haunt the O's. At far left in the second row is a young Ron Swoboda. Swoboda would make a critical diving catch for the New York Mets against the Orioles in the 1969 World Series and bat .400. (Hearst Communications, Inc.)

JAMES ALVIN "JIM" PALMER, ROCHESTER RED WINGS, C. 1964. By 1964, the Orioles system was filled with developing talent. Here future Hall of Famer Jim Palmer shows his signature delivery at Rochester's Red Wing Stadium. Palmer was in Baltimore for the 1965 season and would go 5-4. Eight 20-win seasons were in his future. (National Baseball Hall of Fame Library, Cooperstown, New York.)

ORIOLES MANAGER HANK BAUER. Hank Bauer was a Midwesterner, but having spent a solid decade of his career with the Yankees, he was viewed as a New Yorker when he came to Baltimore. Replacing Billy Hitchcock in 1964, Bauer immediately improved the team and had them in the World Series by 1966. (The National Baseball Hall of Fame Library, Cooperstown, New York.)

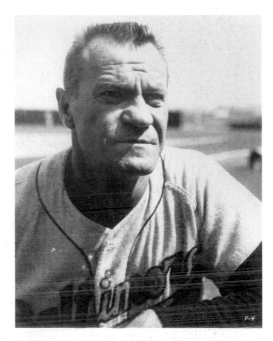

ANOTHER PROSPECT ARRIVES, OUTFIELDER PAUL BLAIR. Originally drafted by the Mets in 1961, Blair was acquired in 1963 by the Orioles organization and seasoned for two years in the minors. Although productive offensively, like Brooks Robinson, he will be best remembered for his work in the field, winning eight Gold Gloves. (The National Baseball Hall of Fame Library, Cooperstown, New York.)

THE FINAL PIECE, OUTFIELDER FRANK "ROBBIE" ROBINSON. Robbie won the MVP for the second time in 1966 but bettered his 1961 performance by taking the Triple Crown in his first season in Baltimore as well. With Robinson in camp, Bauer at the helm, and a supporting cast already assembled, the O's were set for a pennant chase. (The National Baseball Hall of Fame Library, Cooperstown, New York.)

GREAT PITCHING BEATS GREAT PITCHING, THE 1966 WORLD SERIES. A 20-year-old Jim Palmer smiles as he basks in the glow of having outdueled Sandy Koufax in Game Two of the 1966 World Series against the Los Angeles Dodgers. Palmer pitched a complete-game shutout and gave up only four hits as the O's enjoyed a 6-0 victory. (The National Baseball Hall of Fame Library, Cooperstown, New York.)

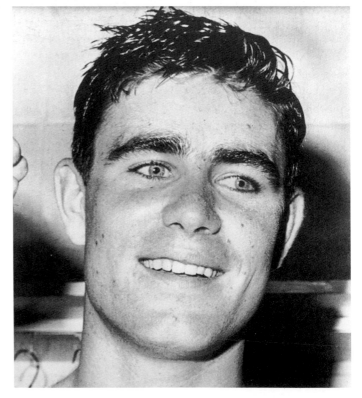

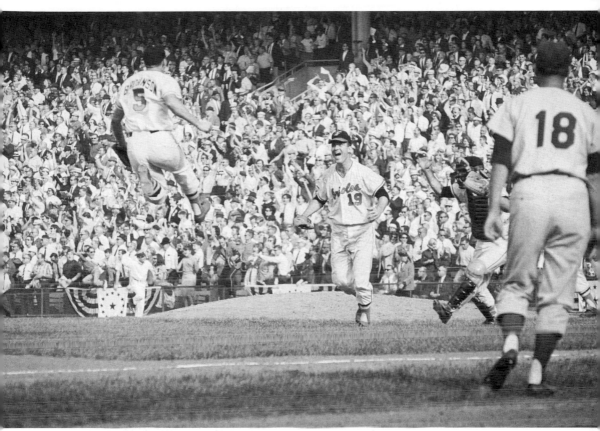

O's Win! 1966 World Champs. Showing off the springs that allowed him to dive towards so many hot shots to third, Brooksy leaps to winning pitcher Dave McNally after the Orioles clinch the 1966 World Series in four straight games. Few would remember it was the same Dodgers franchise that cost Baltimore its NL franchise in 1900, but the foe was fitting. The series numbers will likely never be repeated. Pitching dominated, and the final tallies of the four games, all Baltimore wins, were 5-2, 6-0, 1-0, and 1-0. The Orioles averaged only six hits and just over three runs a game yet swept the series. (© Bettmann/Corbis.)

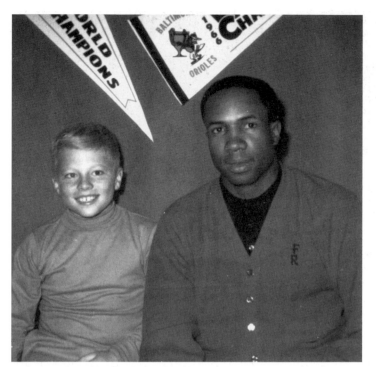

THE KID AND THE KING, WINTER 1966. If a 10-year-old boy could pick any baseball player in history to sit down with, he might choose a player who just won the Triple Crown, the AL MVP, the World Series Championship, and the World Series MVP Award. Joel Jacobson of Baltimore got his pick. Between the 1966 and 1967 seasons, the Orioles made frequent appearances and the fans came out in droves to see them.

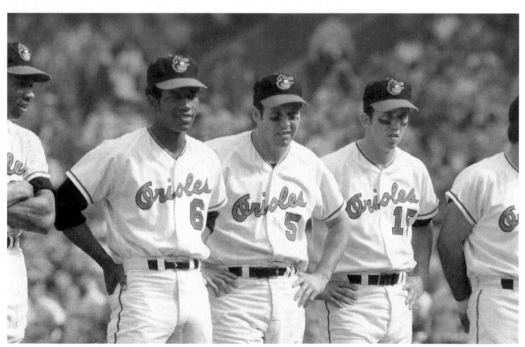

EAGER TO GO, 1970 WORLD SERIES. From left to right, Frank Robinson, Paul Blair, Brooks Robinson, and Davey Johnson are eager to get the 1970 World Series started. In 1969, they were upset by the Mets and look ready to strike it from the record. Their series opponent in 1970 was the powerful Cincinnati Reds. (Getty Images.)

BACK IN THE MAJORS: 1954–PRESENT

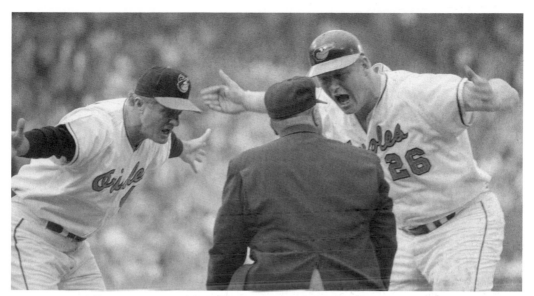

O's Win 1970 Series, Go One for Three in the Decade. Perhaps Earl Weaver (above, left) and Boog Powell would have saved their breath if they knew later that day pitcher Dave McNally would belt a grand slam to help the Orioles win Game Three of the 1970 World Series. They would win the series handily—4-1—and Reds' manager Sparky Anderson was so frustrated by Brooks Robinson's fielding that he quipped, "If I dropped a paper plate, he'd pick it up on one hop and throw me out at first." The two World Series appearances in the remainder of the 1970s, 1971 and 1979, would result in losses to the Pittsburgh Pirates. Both would go to seven games. (Above, © David Hume Kennerly/Corbis; below, Getty Images.)

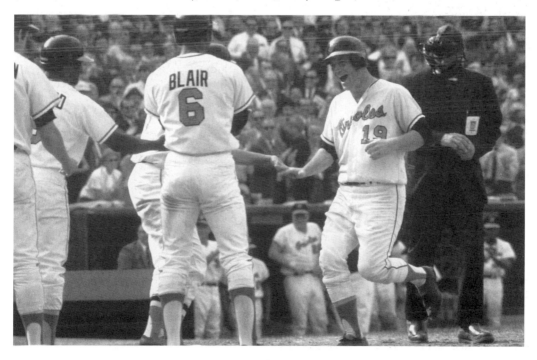

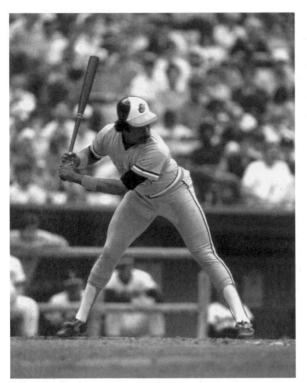

RETURN TO THE TOP, 1983. Eddie Murray, Cal Ripken Jr., and Jim Palmer were three future Hall of Famers on the 1983 Orioles team that beat the Phillies 4-1 to win the World Series. Palmer would retire after the 1984 season and enter the hall in 1990 with a lifetime record of 268-152. Murray (left) and Ripken (below) both had many years of baseball left before retiring and entering the Hall in the 21st century. They each played a remarkable 21 seasons, and the 1983 Series win would be the only of their careers, illustrating the elusiveness of a Series ring for even the game's greatest players. (Both the National Baseball Hall of Fame Library, Cooperstown, New York.)

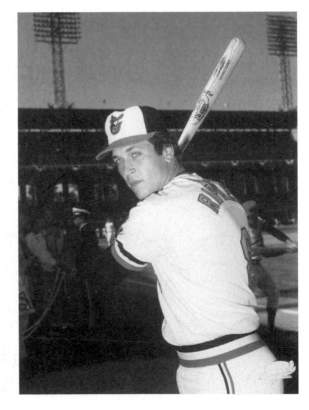

MICKEY TETTLETON AND JEFF BALLARD, THE "WHY NOT?" ORIOLES, 1989. Mickey Tettleton (right) exemplified the 1989 O's coming into the season. His single-season home run best to date was 11, not a high total for a 6-foot, 2-inch catcher with five years of experience. The O's entered the season winning just 54 games the year before, and expectations were nonexistent. A host of new players, including Randy Milligan, Mike Devereaux, and Steve Finley kept the team apace with division-leading Toronto. Eventually the team was dubbed the "Why Not?" Orioles, as they continued to outperform expectations. Drawing into the final two weeks of the season, they were virtually even with Toronto, but ultimately the Jays prevailed by two games to take the division. Tettleton, a switch-hitter, rose along with his teammates and launched 26 home runs, and pitcher Jeff Ballard (below) posted a fine 18-8 record. Under skipper Frank Robinson, they were one of the most exciting teams in Baltimore in the past two decades. (At right, Getty Images; below, © Paul A. Souders/Corbis.)

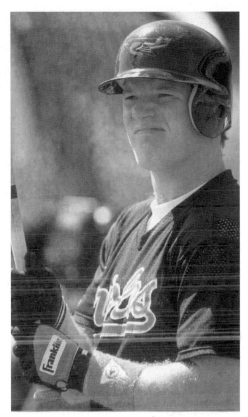

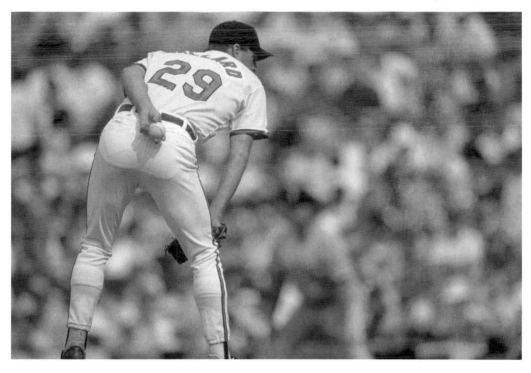

DAVEY JOHNSON RETURNS, 1996–1997. Former Oriole and three-time Gold Glove–winning second baseman Johnson returned to manage the team in 1997. The O's finished second in 1996, and in 1997, the team held first place for the entire regular season. They faltered in the playoffs and there was no Series return. Johnson resigned at the end of 1997 and by 1999 was leading the Dodgers. (The National Baseball Hall of Fame Library, Cooperstown, New York.)

RIPKEN DRIVES THROUGH THE 1990s. Cal Ripken continued to excel through the 1990s for strong Oriole teams as well as clubs that struggled. He won Gold Gloves in 1991 and 1992 and batted in over 100 runs twice in the decade. His crowning achievement was breaking Lou Gehrig's 2,130 consecutive game streak on September 6, 1995. (The National Baseball Hall of Fame Library, Cooperstown, New York.)

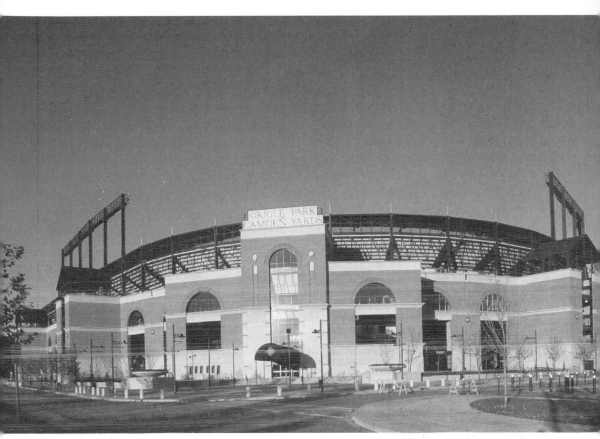

ORIOLE PARK AT CAMDEN YARDS OPENS, 1992. Oriole Park at Camden Yards in downtown Baltimore opened on April 6, 1992, to a capacity crowd of 44,568. The lengthy name is attributable to a combination of two opposing choices by the Orioles' owner at the time, Eli Jacobs (Oriole Park), and then-governor William Schaefer (Camden Yards). It speaks to the distant tradition for Baltimore ballparks to be labeled Oriole Park and also alludes to the location of the stadium at a historic railroad terminal/train yard. The park's design bucked the trend to build combination football/baseball sports complexes outside of city limits, which was prevalent from the 1960s through the 1980s. The outfield fence distances are asymmetrical, and the park was integrated into the city's existing infrastructure and buildings, just as many of the pre-1960s stadiums were. (© Lance Nelson/Corbis.)

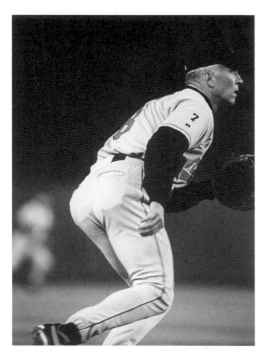

CAL MOVES TO THIRD IN 1996 AND RETIRES IN 2001. In 1996, Cal Ripken Jr. began playing third base as well as shortstop for the Orioles. Early in his career, Ripken played third, and the move was a natural one for an aging star of his size. By 1998, he played strictly third base, and at the end of the 2001 season, he retired after 21 years of Oriole baseball. (The National Baseball Hall of Fame Library, Cooperstown, New York.)

SEND-OFF TO THE HALL, 2007. On Tuesday, July 24, 2007, the Orioles held a special send-off ceremony for Cal Ripken Jr. prior to his journey to Cooperstown for induction in the Hall of Fame. In honor of his consecutive games streak, the Orioles draped the number 2,632 from the Baltimore and Ohio warehouse wall. (Anthony Amobi.)

PLACES CALLED HOME

BALTIMORE'S BALLPARKS

The Madison Avenue Grounds ballpark, in use largely in the 1860s, was probably Baltimore's first built with a notion that fans might be interested in watching baseball. Its successor, 1872's Newington Park, paid even closer attention to the growing crowds and boasted a capacity of 3,000.

The first "great" park in Baltimore was Union Park, built in 1891. Although basic in design, the excellence of the teams it housed elevated it to a ballpark of great stature. The powerful 1890s Old Orioles called it home.

In the early 20th century, the American League Orioles quickly built their own park. Erected in early 1901 just prior to the season, the wooden park initially dubbed American League Park eventually took on the Oriole Park name. Its time as a major-league venue was brief. At the end of 1902, the American League Orioles left for New York, and by 1903, the park was home to the Eastern League Orioles.

It was from this Oriole Park that Jack Dunn could only sit and watch as the upstart Federal League built its larger Terrapin Park just across the street in early 1914. The franchise nearly forced Dunn out of business, but by 1916, the new league had collapsed, and Terrapin Park was his for a song. The park became one of the most loved Oriole Parks.

As the International League O's were en route to seven straight pennants, the Baltimore Black Sox built their own venue, called Maryland Baseball Park, in 1921. The Sox played most of their home games there until the early 1930s, when they upgraded to Bugle Park, built in the city's industrial east end. Bugle would serve much longer as the regular home of the Elites.

A tragic fire in the summer of 1944 destroyed Oriole Park, and the Orioles moved to the city's football venue, Baltimore Municipal Stadium. Over the next decade, Municipal was transformed into Memorial Stadium, and in 1954, it became the new home for the relocated and renamed St. Louis Browns. It served as home to many winning Oriole teams until 1992, when the grandest of all the Oriole Parks opened.

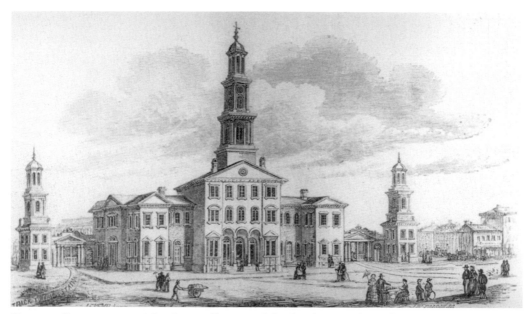

CAMDEN STATION, C. 1860. Ironically, one of the focal points for Baltimore's newest stadium predates the existence of any ballpark in its history and therefore requires first mention. Camden Station was built in 1857, at least one year before any ball field existed for Baltimore's first team, the Excelsiors. (Enoch Pratt Free Library.)

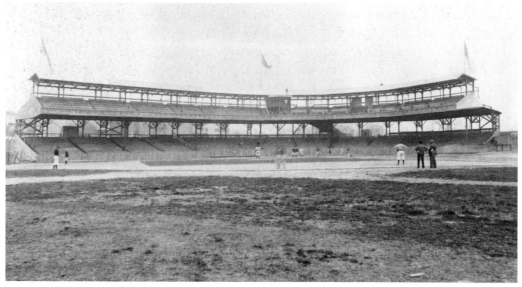

UNION PARK, C. 1898. A handful of parks existed in Baltimore before Union Park, but certainly it was the first "great" ballpark in Baltimore. Built in 1891 for the AA Orioles, it featured an arching two-tiered grandstand behind home. In 1892, it became home to the NL Orioles and was also called Oriole Park. (The Babe Ruth Museum.)

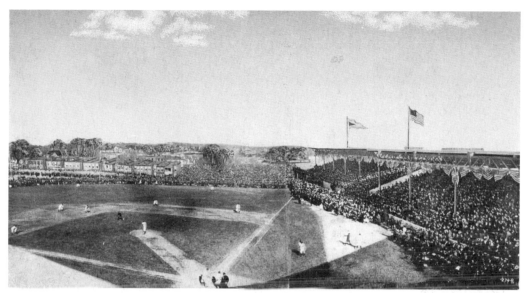

TERRAPIN PARK POSTCARD, C. 1914. The American League Park, pictured on page 30, housed the International League Orioles when Terrapin Park was hastily built in 1914 for the Baltimore Terrapins. Capacity figures vary, but it hosted in excess of 30,000 when the Terrapins began play on April 13, 1914. In 1916, following the Federal League's demise, it became Oriole Park. (Blair Jett.)

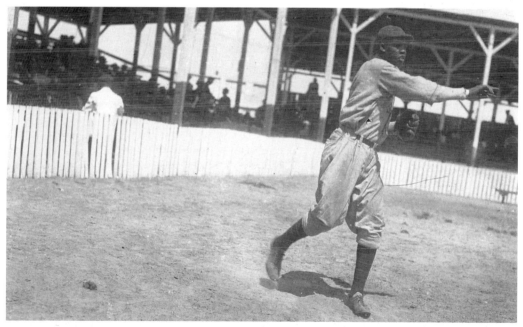

BLACK SOX BALLPLAYER AT MARYLAND PARK, C. 1923. In 1921, two years prior to joining the ECL, the Baltimore Black Sox Baseball and Exhibition Company built Maryland Park. With a capacity of about 3,800, few pictures exist of the overall structure. A glimpse at the grandstand behind this unidentified Black Sox player gives some insight into its structure. (The Maryland Historical Society.)

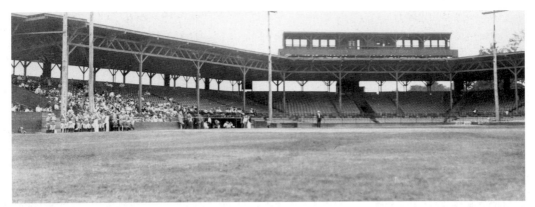

ORIOLE PARK INTERIOR. This interior shot, taken in the 1930s, shows Baltimore's most frequented ballpark from 1914 from 1944. It featured one tier and a rooftop press box, and posts for lighting were added in 1930. The most popular seats in the house on crowded days were literally on the house, as the relatively flat roof offered a lofty perch for better viewing. (The Babe Ruth Museum.)

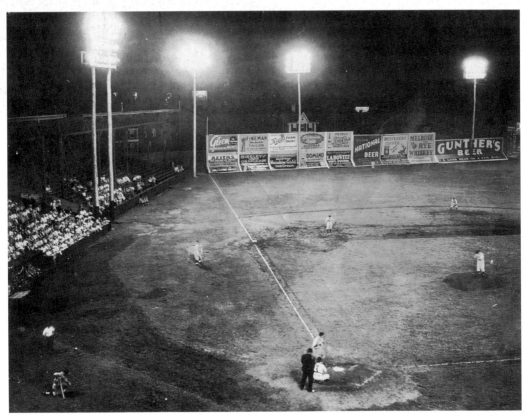

ORIOLE PARK AT NIGHT. Once considered "small-time" by many in professional baseball, the minor and major leagues gradually realized that on weekdays, night games were much easier to attend for baseball's working fans. This shot, taken around 1940, shows Oriole Park under the lights and also reveals an angled base to the outfield wall similar to that at Ebbets Field. (The Babe Ruth Museum.)

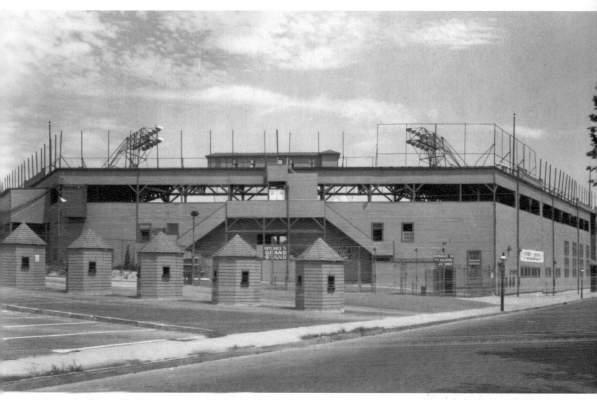

ORIOLE PARK EXTERIOR, 1938. Oriole Park was an impressive structure for its time. It took up a full city block, and the high wooden exterior walls and the ticket booths gave it the air of a fortress, albeit a welcoming one. The large wall along the right field side of the ballpark provided ample room for signage to announce upcoming events or to advertise. When it was built in 1914, it would have dwarfed the existing Oriole Park across the street, which was surely the intention of its builders. Whereas Wrigley Field (née Weegham Park) was built of concrete and steel as the Federal League's flagship, the former Terrapin Park was built hastily and almost completely with wood. (The Maryland Historical Society.)

PACKING THE HOUSE, C. 1938. In the 1930s, poor teams and hard economic times could conspire to keep attendance low at Oriole Park. On this day, there is a large and active crowd, standing and perhaps preparing for the national anthem. Included in this large crowd is a foreshadowing of what would contribute to the park's destruction some six years later: a smattering of fans smoking pipes, cigars, and cigarettes. (Hearst Communications, Inc.)

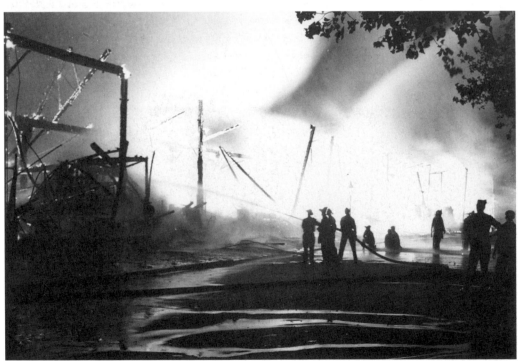

FIRE! JULY 3–4, 1944. After the Orioles' July 3 game, the groundskeeper who typically hosed down the bleachers reportedly doused two small, smoldering fires, which was not uncommon. A third missed his attention, and that night the park was engulfed. Here firefighters wage a losing battle with the flames. (The Babe Ruth Museum.)

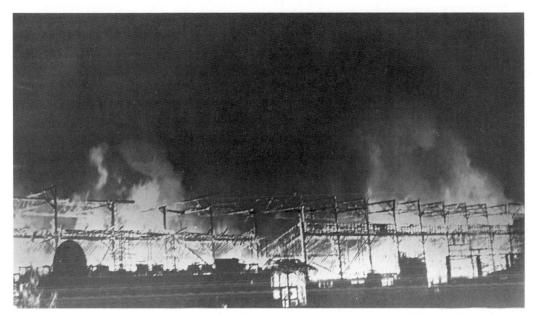

ALL IS LOST. The above photograph clearly shows the complete consumption of the wooden grandstand by flames. The visiting Syracuse Chiefs and the Orioles lost their uniforms, bats, gloves, and spikes. The Orioles immediately went on the road with hastily assembled gear to provide time for Baltimore's Municipal Stadium to be refitted for baseball. The stadium that greeted them two weeks later (shown on page 30) was larger than Oriole Park and drew bigger crowds. In the picture below, team president Jack Dunn III can only stand and grimace as he surveys the scope of the damage with his mother. (The Babe Ruth Museum.)

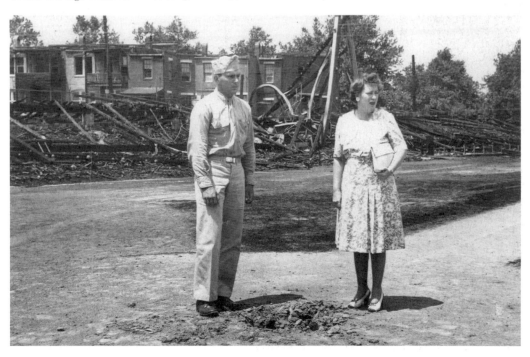

BASEBALL IN BALTIMORE

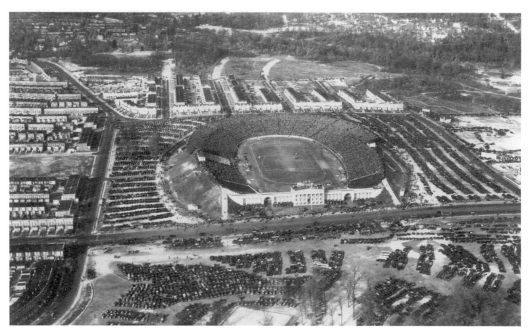

ORIOLES' NEW FOOTBALL STADIUM. An aerial view in 1932 shows a packed house at a bowl-shaped football stadium. Built in 1922 as Venable Stadium, it was renamed and generally known as Baltimore Stadium or Municipal Stadium. By 1944, it was an active venue, hosting a regular slate of football games. Its most outstanding feature when the Orioles arrived may have been its long Greco-Roman classical facade. Chicago's Soldier Field, built in the same era, featured a similarly inspired exterior. Although it looked like the entrance to a football stadium, its size and stature suggested major league, rather than minor league, occupants inside. (Both the Enoch Pratt Free Library.)

BUGLE FIELD, C. 1949. The Elites would sometimes host games at Oriole Park; with its loss they returned full-time to their home at Bugle Field. Bugle Field's owners sold and dismantled the park late in 1949, literally while the Elites were winning the pennant in Chicago. For their remaining time in Baltimore, they played at the city's small Westport Stadium. (The Babe Ruth Museum.)

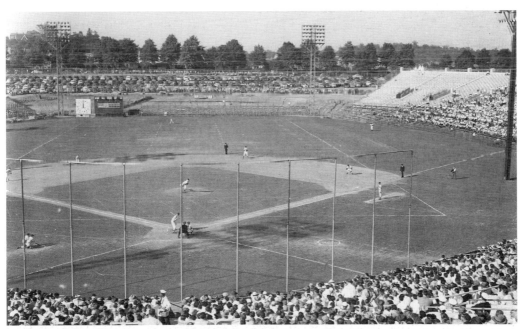

A DEVELOPING BASEBALL FIELD FROM HOME PLATE, C. 1950. Although football markings are clearly on the field, Municipal by 1950 was developing into a combination football/baseball field. Home plate's orientation has changed, parts of the bowl have been razed (as has the old facade), and the once on-field dugouts have been built into the stadium stands.

BASEBALL IN BALTIMORE

A Developing Baseball Field from Center Field, c. 1950. Taken from center field, this clearly shows light posts still in the field of play, near first and third base. These were moved from Oriole Park's outfield, and were likely the only salvageable items from the old ballpark that were incorporated into Municipal. (Enoch Pratt Free Library.)

Memorial Stadium Takes Shape. This aerial photograph shows most of Municipal's replacement, Memorial Stadium, in place. Throughout the significant process of deconstructing Municipal and creating Memorial, baseball and football games were being played, as evidenced in this shot. (Enoch Pratt Free Library.)

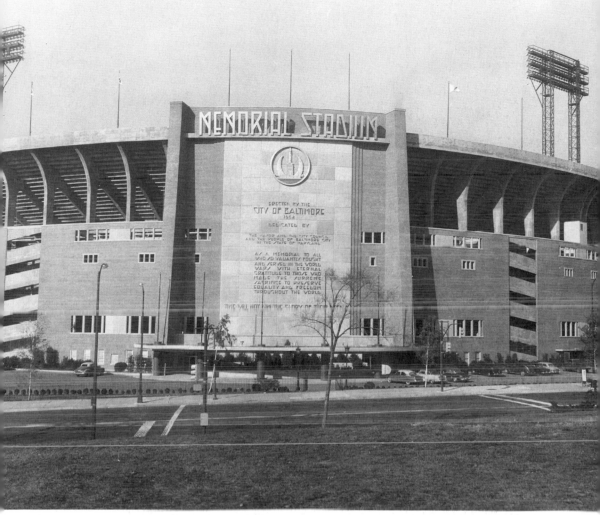

MEMORIAL'S STADIUM'S FAMOUS FACADE, 1954. Although less grand than its predecessor at Municipal, the facade at Memorial Stadium certainly held a more significant importance to its citizenry. "Time will not dim the glory of their deeds" were fitting words for a city and nation just pulling out of an era of three wars in less than 40 years. In a decade they would resound as importantly in remembrance as the nation became embroiled in Vietnam. (Enoch Pratt Free Library.)

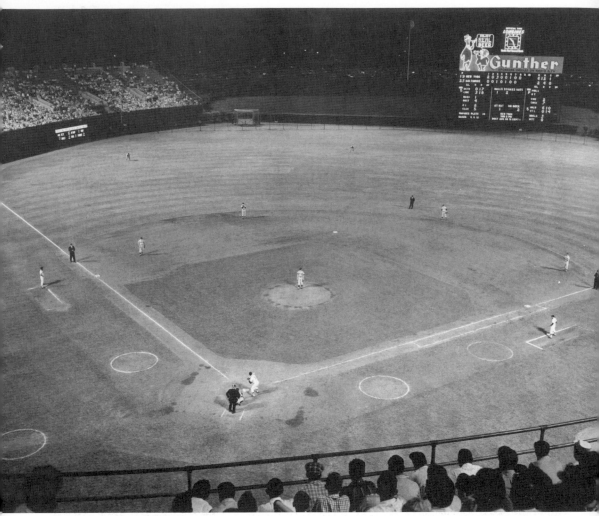

AN AUGUST NIGHT AT MEMORIAL, 1957. By 1957, a great baseball park is firmly in place in Baltimore. With the stadium in center field kept open to facilitate the Colts' football field, fans had a clear view out into the Baltimore sky from the upper deck behind home plate. The Gunther/Longines scoreboard has a long hedge just below it, a small rise behind it, and a stand of trees running along the ridge of the rise. In the center is the American flag. No major-league park today can offer fewer distractions to straightaway center field than old Memorial. (Hearst Communications, Inc.)

PLACES CALLED HOME: BALTIMORE'S BALLPARKS

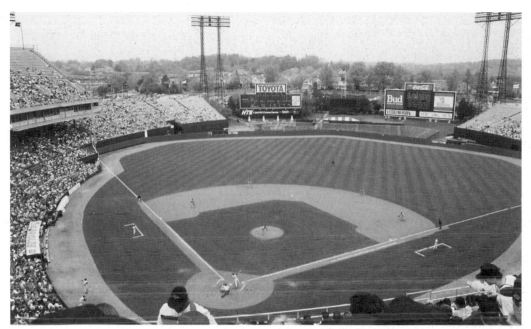

MEMORIAL STADIUM, 1991. By 1991, Memorial's last season as the Orioles' home, an additional scoreboard, some bleacher seating, and a black visual barrier for batters were added to the center field area. Still, the view remained more open than the stadiums built in the 1960s and 1970s. (Paul Locke.)

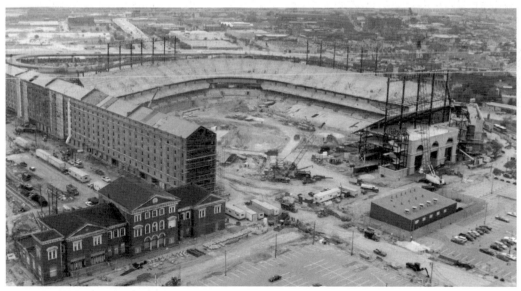

CAMDEN TAKES SHAPE, 1991. At the same time that Memorial was hosting its final games, Oriole Park at Camden Yards was taking shape several blocks from Baltimore's Inner Harbor. It integrated a key structure, the Baltimore and Ohio warehouse, into its design, greatly enhancing the historical appeal of the park. Note the poor condition of Camden Station to the lower left; all three of its decorative cupolas are missing. (Joe Knighton.)

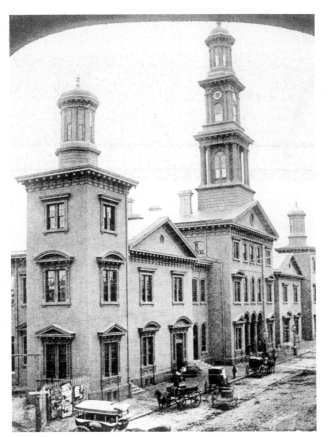

CAMDEN STATION, 1867 AND PRESENT. The lengths to which the designers of Camden Yards went to incorporate or recreate historical detail in the construction of the stadium are nowhere more evident than in the adjacent Camden Station. Under the direction of the architectural firm of Helmuth, Obata, and Kassabaum (HOK), its subcontractors, and the Maryland Stadium Authority, details were either created in the ballpark or restored in the warehouse to enhance the effect of a timeless venue. The Maryland Stadium Authority then completed the picture when it commissioned the architectural firm of Cho, Wilks, and Benn to restore the facade of Camden Station to its 1867 appearance. (At left, Enoch Pratt Free Library; below, @ David Hill.)

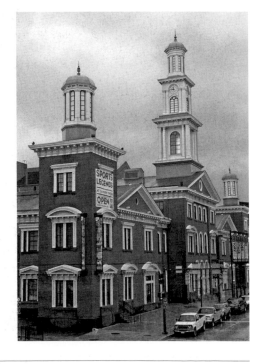

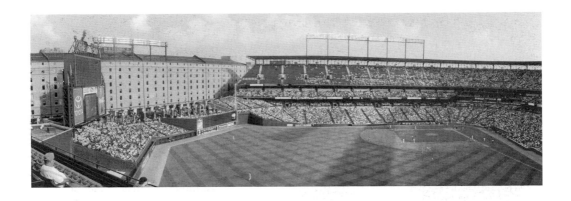

THE BALTIMORE AND OHIO WAREHOUSE, 2007. The Baltimore and Ohio warehouse, which dominates the right field of Camden Yards, was built from 1898 to 1905. Original plans called for its demolition; fortunately later revisions incorporated it into the overall design. Between the warehouse and the right field wall is Eutaw Street, officially closed to traffic but providing an open thoroughfare for fans to walk during the game. (Above, © Wally Gobetz; below, © Andrew Weishaar.)

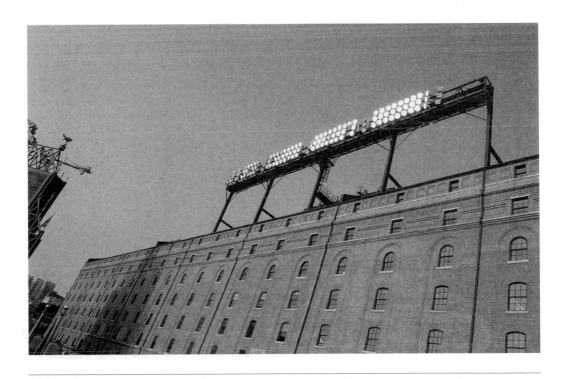

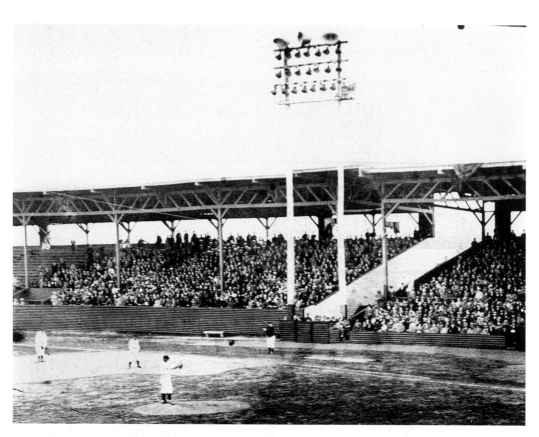

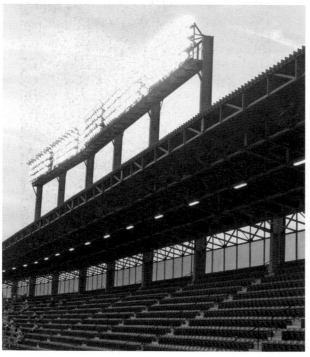

ECHOES OF THE LAST ORIOLE PARK. The Oriole Park built for the 1914 Federal League Terrapins had few frills. It was large, functional, and ready when the Terps took the field that spring. The only discernable decorative effect in the interior may have been the angled wooden beams that served as a facade for the grandstand. Along the back wall of the grandstand also ran a series of three-pronged supports that were less likely to have been decorative. A look up at the current Oriole Park roof reveals a similar effect in steel: angled beams along the facade and a procession of multipronged supports along the back. (Above, the Babe Ruth Museum.)

Babe's Dream Statue by Susan Luery. The Babe, as a native Baltimorean who would go on to star for the New York Yankees, has presented a quandary for Baltimore since they reentered the American League and became the Yankees' rivals. Too much reference to the Babe in the new park design could also include too many Yankee reminders. The problem was resolved when a 16-foot statue of the Babe, sculpted by native Baltimorean Susan Luery, was placed beyond the gates to the park and only miles from where the young Babe Ruth was first taught the game.

ACROSS AMERICA, PEOPLE ARE DISCOVERING SOMETHING WONDERFUL. *THEIR HERITAGE.*

Arcadia Publishing is the leading local history publisher in the United States. With more than 4,000 titles in print and hundreds of new titles released every year, Arcadia has extensive specialized experience chronicling the history of communities and celebrating America's hidden stories, bringing to life the people, places, and events from the past. To discover the history of other communities across the nation, please visit:

www.arcadiapublishing.com

Customized search tools allow you to find regional history books about the town where you grew up, the cities where your friends and family live, the town where your parents met, or even that retirement spot you've been dreaming about.